UIDE to
WORLD MUSIC

Louise Gray

'Publishers have created lists of short books that discuss the questions that your average [electoral] candidate will only ever touch if armed with a slogan and a soundbite. Together [such books] hint at a resurgence of the grand educational tradition... Closest to the hot headline issues are *The No-Nonsense Guides*. These target those topics that a large army of voters care about, but that politicos evade. Arguments, figures and documents combine to prove that good journalism is far too important to be left to (most) journalists.'

Boyd Tonkin,
The Independent,
London

About the author
The music columnist for *New Internationalist* for many years, **Louise Gray** is a London-based writer and editor whose work on music and visual arts has appeared in many broadsheets and magazines, including *The Wire*, *The Independent on Sunday*, *The Times*, *The Guardian* and *Art Review*. She also co-edited *Sound and the City* (British Council, 2007), a book exploring the changing soundworld of China.

Acknowledgements
My thanks to Miguel Vale de Almeida, Marybeth Hamilton, Will Hodgkinson, Gail Holst-Warhaft and Stephin Merrit for permission to quote from their works.

I am grateful to the following for their cheerful co-operation with my many questions and requests for help: Kelvin Birk, Maria Bolesti, Max Carocci, Checkpoint 303, Christopher Somes-Charlton, Charles Darwent, Victor Gama, Pablo Lafuente, Elisabeth Lebovici, Sarah Lowe, Mark Moore, Anne Hilde Neset and Ronni Shendar. I am also indebted to Vanessa Baird, Julian Cowley, Catherine Facerias, Jean Baptiste Kayigamba, Reem Kelani, Matthew Rankin, Alex Rotas, James Sclavunos, David Toop, Elisabeth Vincentelli and Troth Wells for going out of their way to provide me with (variously) contacts, information, translations and often sharing their own ideas and sources. My parents, Jean and Peter Marshall, are responsible for my earliest discussions about music, for which much thanks.

Above all, I am grateful to Laura and Nicholas Gowing for their intelligence, support and forbearance. This book is for them.

About the New Internationalist
If you like this *No-Nonsense Guide* you'll also enjoy the **New Internationalist** magazine. Each month it takes a different subject such as *Trade Justice*, *Afghanistan* or *Clean Start: building a fairer global economy*, exploring and explaining the issues in a concise way; the magazine is full of photos, charts and graphs as well as music, film and book reviews, country profiles, interviews and news.

To find out more about the **New Internationalist**, visit our website at
www.newint.org

The **NO-NONSENSE GUIDE** to
WORLD MUSIC
Louise Gray

WITHDRAWN
UTSA Libraries

WITHDRAWN
UTSA Libraries

The No-Nonsense Guide to World Music
Published in the UK in 2009 by New Internationalist™ Publications Ltd
55 Rectory Road
Oxford OX4 1BW, UK
www.newint.org
New Internationalist is a registered trade mark.

© Louise Gray
The right of Louise Gray to be identified as the author of this work has been
asserted in accordance with Copyright, Designs and Patents Act 1998.

All rights reserved. No part of this book may be reproduced, stored in a retrieval
system or transmitted, in any form or by any means, electronic, electrostatic,
magnetic tape, mechanical, photocopying, recording or otherwise, without prior
permission in writing of the Publisher.

Cover image: Trumpeter leading a procession, Nepal, Kathmandu.
Jacob Silberberg/Panos.

Series editor: Troth Wells
Design by New Internationalist Publications Ltd.

Printed on recycled paper by TJ International Ltd, Cornwall, UK
who hold environmental accreditation ISO 14001.

British Library Cataloguing-in-Publication Data.
A catalogue record for this book is available from the British Library.

Library of Congress Cataloguing-in-Publication Data.
A catalogue for this book is available from the Library of Congress.

ISBN 978-1-906523-12-1

Library
University of Texas
at San Antonio

CONTENTS

Foreword

WORLD MUSIC IS an awkward term for many reasons, not least because it draws an outline round a ghost. However much we try to imagine into being an entire genre of music that is separate from our world and somehow homogenous, the truth is that all musics are connected, even if only very distantly, yet they all express a variance of cultural attitudes, political beliefs, economies, and tactics for working with sound. This is why the moment when world music became a category was so peculiar.

I grew up in the 1950s, when marketing and classification of music was relatively unsophisticated. Listening to BBC radio broadcasts as a child I heard the same forms of music that I would have encountered in many other parts of the world at that time: Latin rumbas, mambos, tangos, and the cha-cha-cha, fake American hillbilly, Scottish songs, Hawaiian guitars, Jewish violins, Gypsy serenades, folk song arrangements, big band jazz, light classics, crooning, and the tail end (mercifully) of the minstrel tradition. Later, just before the pop music machine found out how to target teenage consumers, the phenomenon of novelty records allowed airplay to South African penny whistles, Japanese pop, Nashville country, Greek dances and Italian ballads. In other words, when teenagers like myself discovered Mississippi blues or Indian ragas in the 1960s, this was confirmation that the musical culture of Britain was far more diverse than anybody cared to admit, either then or now.

For those curious about the broadest possible range of musical cultures, London offered as much as you were prepared to seek out. In the 1970s I bought records of Korean Confucian music, Japanese *shakuhachi*, Jivaro chants, modern jazz and Nigerian *juju* and Afrobeat from a thriving network of specialist record shops. Though they were staffed by people who really knew their subjects, these were not scholarly places: the

Nigerian records, for example, were sold at the back of a retail outlet for novelty radios. If you knew where to find them, there were concerts by Tibetan monks from Gyuto monastery, the Fania All-Stars, the Dagar Brothers, Ginger Johnson's African Drummers and Imperial Court Gagaku musicians from Japan. There was the thrill of discovering emergent or staggeringly tenacious musical forms, and then an urgency, a sense of tragedy, derived from the knowledge that entire groups of people were being wiped off the map.

In 1981, some of us started a magazine called *Collusion*, in which we treated all of the music we liked with the same level of curiosity and seriousness, whether it be early hip-hop, Larry Levan, the Bay City Rollers or sacred flute music from Papua New Guinea. Let's say there was something in the air: the Womad Festival launched in 1982; by 1987, as Louise Gray explains in this *No-Nonsense Guide*, a group of enthusiasts professionally involved with global musics coined the term World Music. So they devised what we now describe as a brand. I was working as a journalist in those years and remember the almost indecent excitement with which editors and senior writers on newspapers greeted this initiative. Wait a minute, I felt like saying, what about...? Never mind, each fashion must have its day. Afterwards came the questions raised, of which there were many, not least the problem of what this term might actually mean. To Louise Gray's credit, she confronts these issues with unflinching intelligence, insight, fairness, and a keen awareness of how politics, cultural and contextual differences, fantasies and more prosaic expectations must be taken into account before this remarkable story can be fully understood.

David Toop
Musician, writer, sound curator
London

Introduction

'Listen... I hear the traffic outside; I hear you sitting up; I hear the air conditioning; I hear my foot on the carpet. That sequence of sounds will never, ever, happen again. The only thing that's constant is change.'

Robert Wilson, *The Independent on Sunday*, 2003

WHEN I WAS an undergraduate in the mid-1970s at a university in the middle of England, music on television and the radio was simultaneously limited and sought after – at least by my group of friends. In many ways, we were often not even sure of the music we really liked or gelled with – it was just something, of the most vital importance, that we went looking for. Everything was there to be heard and dissected and discussed and wondered about.

But whatever the enthusiasm with which we greeted our finds, it has to be said that our discoveries lacked any distinct taxonomy. We watched the Open University's televised tutorials (normally broadcast at inclement hours), in the hope of getting lucky, like the time we found Peter Maxwell Davies flinging objects into the interior of a grand piano as he demonstrated how to prepare a piano *à la* John Cage. We got friendly with a bunch of Nigerian political science students who had brought from home some cassettes of a wildly charismatic saxophonist who had set up his own club in Lagos – The Shrine, no less – where he played hugely long, ecstatic gigs, often accompanied by his numerous wives and usually ending in police raids. Then there was the electronic music specialist in the university's music department who had been to Darmstadt and studied with Karlheinz Stockhausen himself: Tim Souster had a hut to himself and one afternoon when I visited, he plugged Radio 2 – the BBC's easy-listening channel – into a sine-wave machine and left me to be

washed by the oscillating waves of sound as he went off to make long phone calls. This was an incident almost as exciting as the demonstration given by the BBC Radiophonic Workshop at my primary school in north London years before. But Delia Derbyshire's unearthly *musique concrète* realization, of an original tune by Ron Grainer, into the most thrilling piece of electronic music ever is another story. We loved with a passion the early music pioneer David Munrow and we mourned when he hanged himself in 1976. Munrow's enthusiasm for his subject – and its potential breadth (for him, there were direct, evergreen links, ideational and otherwise, between the music of the medieval troubadours and that of contemporary folk) – was communicated with such unbelievable verve that it had the effect of flooding everything it touched in an energetic force-field that was capable of defying time itself.[1] And music – that intersection of sound and, sometimes, word – was not to be denied. Privileged and sheltered, I suppose that we were of an age when death could not be easily encompassed.

Teach the world...

But one of the best discoveries was *Ped Pop*. *Ped Pop*, a program we found by chance one night while wandering the radio waves, rejoiced in the name of *Pedagogical Pop*. The program was later to be renamed *Pop Words*, but the principle remained the same. *Ped Pop* wanted to teach the world to sing. In English. Each week, the 15-minute program would choose a well-known pop song and then, line by line, patiently dissect its meaning in an attempt to explain the vagaries of idiomatic English. It was extraordinary and it went something like this. A snatch of music would play – one example was David Bowie's 1969 hit, 'Space Oddity', and its lyric, '*Ground control to Major Tom/ Ground control to Major Tom/ Take your protein pills and put your helmet on*'.

Introduction

'What's his name?' asked Presenter Number One.

'Major Tom,' answered Presenter Number Two.

'Not General Tom,' confirmed Number One.

'Or Sergeant Tom,' said Number Two.

'Or Admiral Tom.'

Ped Pop's breathless pace admitted no doubt. After the whooshy sounds of Major Tom blasting off in his spaceship, the hero is, according to Bowie's lyric, *'floating in a most peculiar way'*.

'Very strange,' remarked Presenter Number One.

'Really odd. Extraordinary.'

Who could make this stuff up? Certainly not me. This dialogue above is reproduced verbatim, because, some 15 years later, while working as a music correspondent for *The Times*, I made a pilgrimage to the World Service in Bush House in London and its basement where *Ped Pop* – by now rechristened *Pop Words* – was produced. The people behind it were delightful and took their work for the BBC's international English-language service seriously. They gave me the script to the 'Space Oddity' episode. It was a small epiphany for me. By 1994, the program was a favorite of millions the world over and the producers' mail bags overflowed with requests (Chuck Berry's 'My Ding-a-Ling' would always be too hot to handle, no matter how many listeners asked for it); comments (perhaps Percy Sledge's 'Take Time To Know Her' could prevent hasty marriages, one West African correspondent wondered); and, on occasion, complaints (Cliff Richard's 'Devil Woman' caused consternation in at least one Kenyan household).

Alas, *Pop Words* is no more, although a cursory glance through the World Service's website does reveal that the BBC retains a commitment to using its resources to explain the terminology of English pop culture to the global masses. But beyond the sheer hallucinatory weirdness of the program, it made me wonder: if English was the lingua franca of pop music,

what did that make pop musics in other tongues? Where were they? And was pop music a monolithic thing, based on three-minute songs, with recognizable instruments, lyrics and choruses? How did pop music differentiate itself from the types of music collected by ethnomusicologists? If *Pop Words* – an invention that was never intended to be a cultural tool of the hegemony of one language over others – addressed itself to the creation of a worldly music, was there a case to be made for world music?

'World' music?

World music is one of those terms that generates questions, not least of which is 'which world'? The implicit assumption inherent in the phrase is that it refers to music not of 'this' world – by which I mean the first or rich/North world that invented the term in the first place – but of 'other' worlds. But one idea I'm ruminating over is that it is now possible to think about what has become known, via a process of cultural shorthand, as world music because of a contemporary sensitivity about the first world's own music – and its place within a larger idea of art in general. I can't date this change exactly, but I believe it to be a development of the past 20 years or so – a period in which a greater reflectivity about music, its culture and most crucially, its context, have come into play. It has meant that music originating in the first world – be it a Shostakovich symphony, produced under conditions of great danger in the Stalin-era Soviet Union, or an analysis of Riot Grrl punk culture in 1990s Seattle – is broadened by being placed in an entirely new network of meaning. When the Australian Nick Cave and the British/Palestinian Reem Kelani, the American Laurie Anderson and the Malians Amadou and Mariam (to pluck four favorites out of my collection) can all be spoken of as 'world musicians' – meaning that they are all musicians in the world, making music for the

world, and not necessarily a series of interconnecting spheres, we will really be making progress.

An interview I once had in 2003 with Robert Wilson, the American-born artist whose name is usually prefaced with a description like 'iconoclastic theater director', sticks in my memory. We had met at the Royal Opera House in London, to which Wilson was bringing his controversial (at least as far as traditionalists were concerned) production of *Aida* over from La Monnaie in Belgium. Around us, the backstage area of the theater was the epitome of focused activity. I said a little to Wilson about the porous boundaries between art forms and how artificial attempts to separate them only hindered a greater and more complex understanding. Wilson suddenly looked interested. 'It's all one concern,' he said in his rich, languorous voice. And so it is.

Louise Gray
London

1 It was in very much in this spirit that David Munrow and his Early Music Consort of London collaborated with Shirley and Dolly Collins on the two folk singers' album, *Anthems in Eden* (Harvest Records, 1969).

1 Inventing world music

'Don't call me "world music" – that's a neo-colonial label you British and Americans like to use for music not sung in English.'
> Manu Chao, *The Guardian*, 1 October 2007.

Whose world and whose music? The uses and abuses of otherness... The problems of record racks... And what happened when the Gypsy Kings hit the big time.

BY ALL ACCOUNTS, 1987 was not one of the most auspicious years in the history of recorded music. Certainly the multinational record companies were doing good business – one could always measure just how good it actually was by the end-of-year parties that they threw, and there were stories of parties with free bars well into the night, parties with funfairs attached, parties designed to continue to court and schmooze the media who in these pre-blog, pre-internet days, were so important to getting the news out and, to use that time-honored phrase, shifting the units. Whatever one's critical opinion of such mainstream artists as – to take three omnipresent 1987 names – Madonna, Whitney Houston and a breathless Australian ingénue called Kylie Minogue, these were the people doing the business, shifting the units, making sure everyone got paid. There was much to be complacent about, at least if you were a company executive.

And yet, there was something dull and utterly relentless about the music that it produced, its modus operandi, its ambition. There was an awful, swollen predictability sounding out in the big anthems blasting out of club speakers and film soundtracks. Those who could pick apart the smoothly produced songs to actually hear their essential emptiness might also have picked up on the jittery energy that ran around the margins of the music industry – in the songs played

on pirate radio stations or in underground clubs, in places where diverse populations with a multiplicity of languages jostled for space to live and play.

New music

If the crackle of this new music was the sound of change, it was one played out in several musical arenas. It was the sound of rap finally breaking through – thanks to pushy, energetic new labels such as Def Jam in New York – and of technological innovation, as the new digital technology became adaptable enough to cope with the memory demands of the growing range of computerized instruments. The United States – or at least its black, gay and very underground club scene in Chicago and Detroit – was responsible for incubating and shaping the new music that was to dominate the next decade. With DJ-producers-composers such as Frankie Knuckles, Derrick May and Juan Atkins lighting the way ahead, something was happening that would see recorded music from all sources effectively recomposed as it was mixed up on turntables, spliced with new samples, fortified with new beats and the noises of the new drum machines and synthesizers that were becoming affordable and available, at least to those in the rich world.

So much noise and with so few items of equipment, or musicians, too: these early forays into digital music offered a seductive journey to a land where a multiplicity of sounds could break away from the limiting factors of history or geographical location. Guided by bold hands, the music created by these machines transcended time and place, the identities of its creators re-edited and reshaped each time a new 12-inch record was produced.

Inventing the name

But 1987 is also significant for another reason. It was the year that world music was invented. Which

is not to say that, prior to the June evening on which 19 men and women met in a London pub called the Empress of Russia, music from the world at large had not existed; it was just that it had not been formulated as such. Many of those attending the pub that night have become hugely significant players in their areas of music: Nick Gold, from World Circuit, the founder of World Circuit Records who went on to produce the Buena Vista Social Club and Ali Farke Touré; broadcaster Charlie Gillett and writer and producer Joe Boyd. Subsequent meetings included broadcaster and academic Lucy Duran, then the Africa expert at the National Sound Archives, and representatives from numerous record labels.

Convened by Roger Armstrong, director and owner of Ace Records and Ben Mandelson, a former post-punk guitarist who was now A&R man, producer and general all-hands-on-deck guy at Ace's GlobeStyle imprint, the group meeting that night had all identi-fied a problem: while they all had great commitment to the music that they loved and promoted, categoriz-ing it was causing real problems in the UK's retail outlets. World music (or what we – speaking from a distance of over 20 years – now understand as world music) was, as Armstrong was fond of saying, simply a 'box in a record shop'.

Up until 1987 there was no agreed generic classifi-cation system for records that took in everything from 'Yemenite pop, Bulgarian choir, Zairean [Congolese] soukous or Gambian kora records' (as the first press release issued soon after by the world music group was to put it) and record stores outside the small cache of dedicated specialist shops were in a flummox. Their confusion was often but an echo of that of the distribu-tion companies which supplied the stores. If the visit-ing reps – the people who suggest new records to the stores – themselves were vague about the records they were recommending that the stores purchase from the

distribution companies, how much harder would it be for the buyers, trying to anticipate demand? And then, at the last point of call, the record-buying public?

Growing interest

It's true that, in Britain, certainly, there was a growing interest in music outside the normal channels which would have undoubtedly helped to inform the public. There was a certain amount of prehistory to this. The Beatles (and especially George Harrison) had brought the Indian sitar master Ravi Shankar to their fanbase in the late 1960s, and as a consequence, the psyche-delic music of the time made cautious attempts to expand its own frontiers.[1]

The influential rock musician Peter Gabriel had launched the now hugely important World of Music, Arts and Dance festival – WOMAD – festival in 1982, complementing this in 1989 with the creation of the Real World record label. In London, there was a small but vibrant club scene that fed an appetite for African and Latin sounds. At Capital Radio, broadcaster and critic Charlie Gillett had been programming world music on his show, *A World Affair* (later *A World of Difference*) since 1983.

And two years later on BBC's Radio 1, DJ Andy Kershaw was developing an increasingly sophisticated rota of world music; he credits the appearance of the Zimbabwean band the Bhundu Boys on his show as 'tipping [him] heavily into African music'. Around the same time, musicologist Lucy Duran was making her first forays into programming world music for Radio 3, the BBC station devoted to classical and the high-art end of experimental music.

All four of the above – Gabriel in terms of festivals and recordings; Kershaw, Gillett and Duran in terms of putting world music onto national radio's agenda – are names that recur in the recent history of world music in Britain. But the three broadcasters did not

spring, fully formed, into action. On BBC radio, there had been, for some years, a smattering of DJs, John Peel chief amongst them, who displayed a demonstrable enthusiasm for the alternative. But even with so important a person as Peel, there was no clear idea of what to do with the music.

John Peel's influence

One album, a compilation of a variety of favorite tracks played on his radio show *Night Ride* (1968-69) and released by the Beeb's own label, was *John Peel's Archive Things LP: Unusual Recordings from the BBC Archive* (BBC) – and the title really says it all. The music – which included a nose-flute quintet from Malaysia, Bugandan royal music played on a xylophone, Australian 'aboriginal' children singing and playing a didgeridoo and songs from Ethiopia, China and, as filtered through the Soviet system, Ukraine, were novelty items. They were marginalized exotica, the sounds of otherness.

'Several of the greatest treats from the depths of the Archives became regular requests, under vague names like "the boot-slapping thing" and "that Russian with the funny voice",' wrote Peel in the LP's sleeve-notes.

The boot-slapping music was, in fact, a gumboot dance from South Africa that is synonymous with the highly rhythmical, stamping *toyi-toyi* dance that is, in turn, synonymous with black South Africans' protest against apartheid in the years before independence. Incidentally, so potent is the legacy of the *toyi-toyi* that it is still used in contemporary South Africa as an expression of disfavor against the government – currently that of the ANC government. Similarly in Zimbabwe, a country that had undergone its own convulsions to achieve majority self-rule in 1980, some years ahead of the collapse of apartheid, the *toyi-toyi* was imbued with such popular restiveness that president Robert Mugabe banned the dance in

2004 as disquiet over Zanu-PF's style of governance grew.[2]

John Peel's intentions were genuine. A life-long champion of all forms of music, his playlists were blessed with an unusually energetic enthusiasm and curiosity for new sounds. But even for someone with an insider's position in so powerful an institution as the BBC, he was also very much the much-loved maverick outsider – remaining so until his untimely death in 2004.

Record label help

The record labels are not totally without credit. Lyrichord, Nonesuch, Tangent and, especially in the francophone sphere, the French label Disques Ocora all did valuable work documenting and releasing music from around the world. Often public libraries stocked releases from the hugely important Smithsonian Folkways label. The record stores were also making attempts to respond to growing interest in 'other' music, whatever it might be called. Some of the chain stores had made their own efforts to categorize the foreign music – Virgin, for example, were already using boards headed 'International/Ethnic' – but it was often the case that any 'International section' in the record racks would be a place where you could find everything that didn't fit easily into the Western pop, rock or folk canon.

Here, new acts breaking through such as Ofra Haza, the Bhundu Boys, Salif Keita and Najma would rub sleeves with such middle-of-the-road Greek crooners as Nana Mouskouri and Demis Roussos; and the ageing French rock star Johnny Halliday or such established greats as Om Kalsoum and Fairuz. Even the Belgian punk band Plastic Bertrand made it into the International selection.

The choice of the phrase 'world music' was not the product of any frenetic advertising campaign, but some-

thing arrived at in an almost haphazard fashion. In his minutes of that first meeting at the Empress of Russia, Ian Anderson, editor of *fRoots* magazine, noted:

> 'It was agreed that we should create a generic name under which our type of catalog could be labeled in order to focus attention on what we do. We discussed various names for our type of music(s) and on a show of hands "World Music" was agreed as the "banner" under which we would work. Other suggestions were "World Beat", "Hot...", "Tropical..." and various others. It was suggested that all of the labels present would use "World Music" on their record sleeves (to give a clear indication of the "File Under..." destination) and also on all publicity material, etc.'
>
> *www.frootsmag.com/content/features/world_music_history/minutes/page03.html*

'Yes, it did go through on a show of hands – it was the least worst option,' GlobeStyle's Ben Mandelson told me in 2008. It was a title, a descriptor, that was intended to embrace rather than exclude many musics that were by definition not getting their best shots at reaching markets and eager ears. Moreover, the Empress of Russia group had noticed, from recent history, that other non-mainstream musics such as folk, bluegrass and country were all ones that had achieved a level of success and visibility precisely because the same interested parties – that is, the record companies, the distribution companies and the shops – had all begun a measure of collective action. 'We didn't even have longevity as an aim of our meeting,' Mandelson continued. 'And we weren't doing anything as radical as inventing a genre with rules about who could join and who couldn't. But as record companies, we do have an obligation to our artists to get their records

out there. Our compact as a record company is to put music in front of those people who might like it.' Thirteen years later, Anderson elucidated the decision in an article published in *fRoots* (see box **The birth of 'world music'**).

The Empress of Russia group nominated October 1987 to be World Music month, during which adverts in the popular and retail press plus a cover-mounted cassette given away free with the *NME* – Britain's biggest-selling music newspaper – would introduce readers to the concept of world music.[3] And so it happened. Armstrong, Mandelson and Roy Carr, an *NME* veteran who had become its special projects editor, produced a cassette entitled *The World at One* and featuring musicians such as Nusrat Fateh Ali Khan, Salif Keita and Ofra Haza on its playlist. Bob Marley, the Jamaican reggae musician who can justifiably lay claim to being one of the most important international artists ever, fell outside these nascent

The birth of 'world music'

'[World Music] wasn't a new name, just one of many that had floated around in the preceding decades.'

'But the logic [was] set out by Roger Armstrong that an established, unified generic name would give retailers a place where they could confidently rack otherwise unstockable releases, and where customers might both search out items they'd heard on the radio (not knowing how to spell a mispronounced or misremembered name or title) and browse through wider catalogue. Various titles were discussed including "Worldbeat" (left out anything without drums), "Tropical" (bye-bye Bulgarians)' – this a reference to the cult choral hit album from the Bulgarian State Radio and Television Female Voice Choir titled Le Mystère des Voix Bulgares and released by 4AD in 1986 – "Ethnic" (boring and academic), "International Pop" (the death-by-Johnny-[Halliday]-and-Nana-[Mouskouri]-syndrome) and 'Roots' (left out Johnny and Nana). "World Music" seemed to include the most and omit the least, and got it on a show of hands. Nobody thought of defining it or pretending there was such a beast: it was just to be a box, like jazz, classical or rock...' ∎

(*fRoots*, March 2000).

Bob Marley

However you want to categorize Bob Marley, the one uncontentious fact is that the man was a superstar whose music, at the time of his death in 1981, symbolized a rich mix of rebellion and transcendentalism. Jamaican music had made sporadic inroads onto international playlists before Marley, but it was his blend of roots reggae, Rastafarian iconography and pop sensibility that burst through to global markets. Born into inauspicious circumstances in Jamaica in 1945, Robert Nesta Marley was the son of a white British officer and a young black Jamaican woman, Cedella. Growing up in Kingston's Trench Town (an area that would later feature in his songs), he was exposed to the range of popular music that Jamaica offered: mento pop, gospel (with its emphasis on a spiritual homeland), ska and rocksteady. Marley was blessed with a light voice and a canny ear for melody. Starting out from rocksteady beginnings with a band that would feature Peter McIntosh (later Tosh) and Bunny Livingston (later Bunny Wailer), Marley took up reggae's jolty rhythm and took it to a new place. *Catch a Fire* (1973), *Burnin'* (1973), *Natty Dread* (1974), *Rastaman Vibration* (1976) and *Uprising* (1980) – all released by Island Records – have become multimillion-selling albums, all as important in terms of cultural shifts and sheer imperviousness to time as those of the Beatles or Elvis. At this level, it is nonsense to think of Marley in any category other than as a musical colossus whose music straddles the world. ■

attempts at taxonomy (see box **Bob Marley**).

It was all good stuff: some of the musicians on the *The World at One* tape went on to make huge international names for themselves (Israeli superstar Ofra Haza chief among them), others remained with a quieter reputation. Once the huge US market had quickly bought into the world music idea, the phrase was secure. By 1993, Dan Storper's Putumayo World Music – a record label specializing in compilation albums – had begun its phenomenal upward trajectory. Putumayo, once a clothing shop, had branched into music via mix tapes. By 2008, it had sold over 20 million albums, helped the careers of countless musicians and bucked the general consumer trend towards buying music by download alone.

Yet, despite the evidence that the newly coined world music was building a growing audience, a momentum

was necessary to reinforce the new category. And this had already appeared, in the form of an album which would push world music, its appropriation and politics to the fore, made by a singer-songwriter at the very heart of the Western popular canon.

Graceland's impact

The 1986 release of Paul Simon's album, *Graceland* – one year before the Empress of Russia meeting – was always going to be a major event. But few albums have ever generated so much controversy and fewer albums still have university courses taught about them and, probably, learned books in the offing. Simon, who had established himself nearly 20 years earlier as one half of the best-selling duo Simon and Garfunkel, was royalty. With Art Garfunkel, Simon had authored songs that had encapsulated an aura of Sixties America. Although less brittle (or changeable) than Bob Dylan, the marked softness of the duo's tone should never be taken as a trope for their intent. There was a sour melancholy at the heart of their music: the sheen on golden youth, they seemed to suggest, was always one of gilt.

Even so, no one had marked Paul Simon's card as a troublemaker and, more specifically, one who supported the apartheid regime then in place in South Africa. Of course, he was not and never had been a supporter. Simon's own antipathy towards South Africa's political system is well documented. The problem was that both the African National Congress and UNESCO had imposed a cultural boycott on foreigners working with Pretoria in any way that could be seen to shore up the regime – and part of Graceland had been recorded in South Africa, with black South African artists playing township jive and Zulu-originated *mbaqanga* alongside Simon's soft rock.

Which way to go? Was *Graceland* just a combination of superb music accompanied by some naïve

politics? (The *New Internationalist* magazine gave it one star for politics and five – the highest score – for entertainment in a review published in January 1987.) In truth, the situation was a vexed one. *Graceland* was a record that was a product of much collaboration. South African band Ladysmith Black Mambazo played on it; so too did the exiled trumpeter Hugh Masekela. The international clout wielded by someone such as Simon meant that many of the artists got some decent international exposure, something that was good for their careers and their incomes. And, as the debate raged, the album was selling millions worldwide.

But *Graceland* was not the only audible point of promised change. Even as listeners in the first/rich world were extending their definitions of popular music in all directions, very much on a cusp of wanting and waiting for something new, sounds that would shake things up – along came the Gipsy Kings.

Enter the Kings

The Gipsy Kings, an affable band of *Calé* or *gitano* musicians whose parents had crossed the Pyrenees into France during the years of the Spanish civil war and who were initially led by the flamenco-singing legend Jose Reyes, hailed from an unfashionable area of southern France. Specifically, they came from a *cité* outside Montpellier named, infelicitously, after the ancient Greek word for fear, Phobos.

While it is probable that the new *cité*'s naming had more to do with astronomy – Phobos is also one of two moons orbiting Mars – the area certainly was born under inauspicious signs. A satellite town, constructed in the 1970s as a government response to a growing demand for public housing, in particular to accommodate immigrants, Phobos was not exactly a *banlieue* (suburb) in the way that the word is now understood at the beginning of the 21st century.

Inventing world music

Phobos was not like contemporary suburbs of Paris and France's other great cities, some of which are strife-torn zones full of high-rise apartments and low opportunities. But as a brand-new conglomeration, Phobos lacked enough history, enough social glue to give it any kind of cohesion when the bad times came. The *cité* ultimately failed and exists now only in the memories of its former inhabitants. Bulldozed just 20 years after its founding, Phobos became, to coin a French phrase that poetically conflates invisibility with death, *la cité disparue*.

But what does the fate of an ill-conceived experiment in urban planning have to do with the Gipsy Kings? Quite a lot. The *cité* was not only a kind of home from home for what was essentially a band of eight musicians from two related families, the Reyes and the Baliardos, but also a sonic crucible.

Mix of music

In their suburban environment, the young Kings would have heard much more than the traditional flamenco that was to form the base of their *rumba catalana* (a popped-up version of flamenco) and, as their career took off, led to global sales that numbered in the multimillions. Phobos would have also reverberated with the sounds of *raï* and the sobbing cadences of its *chebs* (singers) simultaneously homesick for, and sick of, Algeria; of proto-blues from such Francophone countries as Mali and Senegal; of reggae and the dance-dance-dance imperative broadcast from any radio or TV station that favored Europop's breezy and untroubled beats. In short, like any multicultural place, Phobos was a community of sounds. It resonated with a world music.

The Gipsy Kings' self-titled album was released in November 1988. Its instrumentation was, for the type of music it espoused, pretty predictable: in addition to the vocals, there were guitars, drums and percussion,

lots of hand-clapping – and a little digital intervention with the use of some synthesizers. Of all its dozen tracks, it was the upbeat 'Bamboleo' that caught the world's attention. After *The Gipsy Kings*' US release the following year, the album spent some 40 weeks in the American charts, something unheard of for a Spanish-language release.

All seemed good in the world of *rumba catalana*. And then, just when the Gipsy Kings were at their flamboyant flamenco peak, music critics caught hold of a rumor that chilled them to the bone. The Kings, it seemed, were anticipating their royalty checks with feverish impatience: they had their eyes on banks of electronic keyboards, synthesizers and plug-in drums. With the predictability of night following day, the debates – far older than Bob Dylan going electric – began: how authentic can a group playing traditional music be when they use non-traditional means?

In the event, there wasn't much substance to the Kings story – and, whatever the truth of the matter, the rumor has done their career precisely zero damage. The Gipsy Kings are, at the time of writing, still going strong; their album sales now number over 18 million; they are laden with platinum discs, Grammys and other awards. Good luck to them.

Search for 'authenticity'

Nevertheless, this story neatly illustrates the problems associated with notions of authenticity – and its charge that any contact with outsider elements pollutes the original material. The same debates will certainly take place in relation to Konono No 1, the extraordinarily resourceful 12-piece from the Democratic Republic of Congo (DRC) that sprang to international conscious-ness in 2005 with the release of a debut album that was 25 years in the making. With few resources other than a predilection for Bazomo trance music and a handful

Merritt on authenticity

'The question of authenticity seems to be something that's moot and connected with... distance. [Ethno-musicologist] Alan Lomax went around making field recordings of toothless octogenarians in the Deep South. He knew perfectly well that he was making stars of these people, and what he was recording was their very toothlessness and octogenarianess, and that was cool, whereas a 30-year-old with all their teeth just wouldn't have been glamorous for Lomax. He had an inverted glamor which was directly comparable to Warhol's point-and-click films of transvestites and drug addicts and he ended up with the same process.' ∎

Stephin Merritt to Louise Gray, *The Independent on Sunday*, 2000.

of traditional instruments, Konono's founder and *likembé* (thumb piano) virtuouso Mawangu Mingiedi assembled a raft of the most rudimentary percussion and amplifiers imaginable from old car parts found in the scrap yards of Kinshasa. *Congotronics* (Crammed Discs) is not just electrified traditional Congolese music, it is also a masterpiece of bricolage, aesthetic and actual. One might add the Bedouin Jerry Can Band from Egypt's Sinai Desert, a group that describes itself as a 'collective of semi-nomadic musicians, poets, storytellers and coffee grinders', and makes music on the traditional lyre – the *simsimiyya*, reed pipes, flutes and old ammunition boxes and jerry cans left over from the Six-Day War in 1967.

Interestingly, the pros and cons of the authenticity debate have been stated most vehemently in the field of Western classical music.

Authenticity is one of those concerns that permeate many discourses: sociological, anthropological, linguistic and creative. It's an interesting idea, but also a spurious one. How do we hear? What do we see? There are as many ways of approaching music as there are separate cultures. We all bring something of our own background into contact with new experiences. Even in writing a word like 'separate', one is

aware that separateness is a fiction. Increasingly, in this linked-up world, cultures, experiences, sounds, politics and aspirations coincide, rather like a Venn diagram of overlapping circles. Each sound, each idea – they all have porous boundaries. To insist on the very existence of the authentic experience becomes an exercise in pursuit of a dubious purity, a kind of battening down the hatches to keep the world of ideas at bay.

World music is the subject of this book, but what it is exactly is an elusive thing to pin down. 'Music' we understand as a portmanteau term – it describes so much, both in terms of organized sound and the ambient. To listen to the music of lost Phobos would have been to hear not just the songs emanating from the *cité*'s radios, but also the incidental clamor of unintentional musics in the rhythms and counter-points of speech and language, in the revvings of passing cars and the slippage and elisions of sounds from one register to the other.

As the experimental composer John Cage pointed out in his silent work *4' 33"*, there is a world of sound to be heard wherever we care to listen. But the 'world' bit of world music is far more problematic.

Delta blues

'To excavate the idea of the Delta blues is to describe something more amorphous and intangible: a history of voices and responses to voices, of the memories and emotions they generate, of how those associations change over time. What emerges from [the folklorists, critics and collectors'] stories is a genealogy of feeling and sensibility. The idea of a genuine, uncorrupted black voice has long had a potency that goes far beyond music. The Delta blues, in essence, was the end product of a journey of the imagination, in which the search for authentic black voices came to focus on commercial blues race records – and remade the blues itself in the process.' ∎

© Marybeth Hamilton, from *In Search of the Blues: Black Voice, White Visions* (Jonathan Cape, 2007, p 18).

Inventing world music

Which world does it refer to? Whose world? Not the entire world, clearly: Michael Jackson, the Rolling Stones and Madonna (to pluck three internationally big sellers from the racks at random) are not world music. Tinariwan, the band made up of Tuareg nomads; Fela Anikulapo Kuti, the Nigerian inventor of Afrobeat; and the Siberian overtone singer Sainkho Namchylak are, in the classifications of record shops, decidedly world music. Less attention is given to the fact that Tinariwan are arguably inheritors of an indigenous African blues tradition; that the saxophonist Fela Kuti revitalized jazz by offering the new horizons of Afrobeat; and that Sainkho (as she is usually known) is as often to be found in the most serious avant-garde performance circles as she is on the popular stage.

English rules the world
A quick glance over the names listed above shows they hold one thing in common. Michael Jackson, the Rolling Stones and Madonna all sing in English. The writing, production, making and diffusion of their music is supported by a well-developed industrial apparatus that is based in the first or rich world and honed to a lithe reflexivity by decades in the business.

Of course, singing in English is no guarantee of commercial and critical success, but for an artist to engage with the very hegemony of the English language is for them to expose themselves to global markets. There is a small exception to this: it was, even until the 1980s, relatively common for some leading pop artists to re-record their songs in other languages to favor more local markets, but this seems to be a practice that is dying out.[4] While music has always been subject to a process of rudimentary taxonomy, simply for the ease of differentiating certain traditions from one another, the more contemporary classifications we use as shorthand for

music are driven by the impetus of marketing. They are also wildly inaccurate. So if 'world music' is little more than a marketing tag, who's writing the advertising copy? The simple answer is the sellers.

This is not a terrible situation. Sellers need to be pro-active in order to survive; and, as we have seen with regards to the people who met at the Empress of Russia, it's absolutely necessary for the sellers to negotiate a way to represent their own and their artists' interests. Neither world domination, nor belittling the musicians who would later fall into the world music category was on their agenda – even though there are many who are uneasy with the tag. 'Don't call me "world music",' the French-Spanish star Manu Chao told *The Guardian* writer Garth Cartwright in 2007. 'That's a neo-colonial label you British and Americans like to use for music not sung in English.'

Poking fun: 'World Love'

When the rhythm calls
The government falls
Here come the cops
From Tokyo to Soweto
Viva la musica pop
We are black and we dance all night
Down at the hop
And the letters were tall
On the Berlin Wall
Viva la musica pop
So if you're feeling low
Stuck in some bardo
I, even I
Know the solution
Love, music, wine and revolution
Love, love, love
Love, music, wine and revolution... ∎

The Magnetic Fields, 'World Love', from *69 Love Songs* (Merge), © Stephin Merritt 1999. Published by Gay and Loud /Notting Hill Music. Reproduced with permission.

Inventing world music

'We are the world' happy-clappy

Others detect a certain naïvety in the term. Stephin Merritt, the sharp-edged American songwriter behind several American bands, the Magnetic Fields (see box **Poking fun: 'World Love'**) most famous amongst them, mocks the one-world, one-love inclusivity that sometimes permeates the wider culture of world music, with its bland call to happiness, typified by USA for Africa's 1985 fund-raising anthem, 'We Are the World'.

And David Byrne, a musician who together with Brian Eno released one of the most influential world music albums ever in 1981 – *My Life in the Bush of Ghosts* – penned an article in *The New York Times* headlined, 'Why I Hate World Music':

> 'I hate world music... The term is a catch-all that commonly refers to non-Western music of any and all sorts, popular music, traditional music and even classical music. It's a marketing as well as a pseudomusical term – and a name for a bin in the record store signifying stuff that doesn't belong anywhere else in the store. What's in that bin ranges from the most blatantly commercial music produced by a country, like Hindi film music (the singer Asha Bhosle being the best known example), to the ultra-sophisticated, super-cosmopolitan art-pop of Brazil (Caetano Veloso, Tom Zé, Carlinhos Brown); from the somewhat bizarre and surreal concept of a former Bulgarian state-run folkloric choir being arranged by classically trained, Soviet-era composers (Le Mystère des Voix Bulgares) to Norteño songs from Texas and northern Mexico glorifying the exploits of drug dealers (Los Tigres del Norte). Albums by Selena, Ricky Martin and Los Del Rio (the Macarena kings), artists who

sell millions of records in the United States alone, are racked next to field recordings of Thai hill tribes. Equating apples and oranges indeed. So, from a purely democratic standpoint, one in which all music is equal, regardless of sales and slickness of production, this is a musical utopia.'[5]

Distinct roots

Kudsi Erguner, the renowned Sufi musician and *ney* (a reed or bamboo end-blown flute) virtuoso, detects certain dangers in the rush to embrace the tag of world music, not least in the loss of highly specific contexts. Erguner's fascinating memoir, *Journeys of a Sufi Musician*, contains many examples of this. He traces the way that the dance of the whirling dervishes has been, to a great extent, detached from its original religious context to become a folkloric spectacle.

Sufism, along with many other forms of traditional Turkish expression, including music, was suppressed by Atatürk's new Turkish republic as having retrogressive tendencies. And, as a master musician himself, someone whose long training was rooted in the subtleties of classical improvisation, Erguner mourns the inevitable loss of craft that comes with a widening of an audience. With the appearance of 'world music', he writes, 'the traditional musician begins to emphasize virtuosity to obtain a music more flattering and easy to listen to... Traditional music was corrupted by

Kudsi Erguner

'Sometimes I find myself dreaming of a world that is not "Eurocentric"... Imagine the situation reversed, the Middle East dominating the rest of the world. Imagine then, an ethno-musicologist from Baghdad researching German music. If he wrote that Bach belonged to German folklore, would this not appear strange to a European?' ■

Kudsi Erguner, *Journeys of a Sufi Musician* (Saqi, 2005).

conforming to the tastes of a less and less educated audience.'

Chao, Byrne, Merritt, Erguner: they all have a point. Designating certain artists as 'world' ones can imply that they're not popular enough to be mainstream. But then, who is mainstream? Are the blind Malian duo Amadou and Mariam, whose Manu Chao-produced hit *Dimanche à Bamako* is a zappy, happy pop album of the first order, mainstream? Are England's Martin Carthy and Norma Waterson constellation – the stars of British folk – world music? Is the Australian indigenous singer Kev Carmody (part Irish, part Muri), a musician who has been described as Australia's Bob Dylan, best categorized as folk or world or even experimental? Is Jamaican reggae – a beat so important to the British punk scene of the late 1970s – world music? And if so, where would one place producers such as Lee 'Scratch' Perry or the Mad Professor (aka Neil Fraser), two of the genre's most significant and prolific experimenters? It's a contentious area. If we have to categorize, maybe one way of beginning would be to ask the musicians themselves and examine the creative frameworks within which they work.

Why now?

But even if we suspend a well-founded reticence to use the term 'world music', there are immediate questions to be asked. Prime amongst them is this: why is world music so interesting to the first world – its main consumers – now? World music is not new. The existence of musics outside the rich West has been known since travelers first traveled. It has been actively sought out and notated, by folk-song collectors such as Cecil Sharpe in Britain or John and Alan Lomax in the American Deep South; also by composers such as Bartok, John Adams and Kevin Volans.

The work of the American classical composer Steve Reich is fundamentally informed by African music and, via Philip Glass's work with Ravi Shankar, a whole school of post-1945 music – minimalism – is intimately tied to Indian ragas and their microtonal scales. Since the late-19th century, the capacity for recording sound on cylinders, discs, tape and, most recently in digital formats, has meant that the work of learned archives, filled by ethno-musicologists and others in fieldwork excursions the world over is becoming available to the many rather than the few.

This *No-Nonsense Guide* is a modest book, one which hopes to ask questions about the thing we conveniently describe as world music. It is not an exhaustive survey, replete with musicological insights. For that, readers are recommended to seek out the excellent (and regularly updated) *Rough Guide*'s volumes on the subject. Nor is this book intended to be (or capable of being) a sociological study of music, its audiences and its distribution. For that, readers are directed to more academically orientated journals such as *Popular Music and Society*. Musicologists of all figs are served by many other publications. The scholarly *New Grove Dictionary of Music and Musicians* is too expensive for most individuals to own alone, but as a tool to be accessed either in libraries or online, it is an essential one.

Rather, what this book hopes to do is locate several manifestations of world music within a larger context. Its basis is that music is expressive of an idea of community, and that singing, and the involvement in singing – in acting in concert – underpins this idea. What of those outsiders who visit these musical communities? What is it that they – we – bring to the places they visit? What yearnings do we project onto what we hear? Could it be a complex longing for a simple idea of community itself? Listening to music

outside one's own culture is, at its most basic level, an enriching, world-widening experience. It is a contact with the outside world. And this, along with the outsidership implied, plus all the fantasies, romantic and otherwise, are the subjects of the next chapter, where the focus is on Portuguese *fado* and the *rembetika* of Greece.

1 In addition to the Beatles, sitar sounds made appearances in songs by the Yardbirds, Traffic and the Rolling Stones, among others. 2 Formerly the British colony of Rhodesia, the country was cut adrift from the Commonwealth following its unilateral declaration of independence in 1965, after a refusal to countenance power-sharing with the black majority. 3 The tracks on the *NME*'s *World at One* (NME 035) cassette (1987) were as follows. Side 1: Salif Keita *Sina*/Najma Akhtar *Dil Laga Ya Tha*/Yanka Rupkina with Trakiistra Troika & Kostadim Varimezov *Ot Kak Se Mara Rodila*/Kass Kass *Mister Oh!*/Yiorgos Mangas *Choreptse Tsifteleli*/Sidiki Diabete & Ensemble *Ba Togoma*/Ketama *No Se Si Vivo O Sueno*/Zouk Time *Guetho A Liso*/Abdul Aziz Mubarak *Ah'Laa Jarah*. Side 2: Ofra Haza *Galbi*/Hukwe Zawose, Dickson Mkwana & Lubeleje Chiute *Nhongolo*/Shirati Jazz *Dr Binol*/Nusrat Fateh Ali Khan *Ya Mohammed Bula Lo*/The Real Sounds Of Africa *Murume Wangu*/Jali Musa Jawara *Fote Mogoban*/Dilika *Amazimuzimu*/Sadik Diko & Reshit Shehu *Valle e Gajdes*/Jorge Carbrera *A Fuego Lento*/Sasono Mulyo *Gamelan Gon Kebyar*. 4 English-language songs have always been a popular way for non-native speakers to learn the language. *Pop Words*, until relatively recently a weekly radio program broadcast on the BBC World Service, was one predicated on this activity. Perversely, it seems that increased access to broadband now means that these kinds of program are no longer necessary. It is easier now to access websites that reproduce song lyrics than to record and listen to pedagogical programs. 5 David Byrne, 'Why I Hate World Music', *The New York Times*, 3 October, 1999. Byrne's polemic is also reproduced on the Luaka Bop website, www.luakabop.com/david_byrne/cmp/worldmusic.html.

2 Music on the margins

'The fado, the knife and the guitar are the three favorites adored by the people of Lisbon.'
> Pinto de Carvalho, *Historia do Fado* (1903).

'[Rembetika] is the music of knife fights and decadence.'
> Nikos Zachariades, quoted by Ed Emery,
> Introduction to Ilias Petropoulous, *Songs of the Greek Underground* (Saqi 2000).

Grime and crime – down and out in Lisbon and Athens with fado, rembetika and the aura of the other... Folk music and the dictators... The limitlessness of liminality.

ANY CONTEMPORARY VISITOR to the slopes of Lisbon's Alfama district could be forgiven for thinking that *fado* – Portugal's great surging song of melancholia – was ever an endangered species. Alfama is the oldest district in the capital city and it retains many of its medieval bearings. A multitude of tiny restaurants on equally tiny, winding streets offers travelers simple, homely fare, but robust music.

In these little restaurants, where the floor space is often no bigger than a standard living room, there's no telling who the *fadista* (fado singer) will be until the moment to stop serving the food and start singing the song arrives. And only then, when the cook comes out of the kitchen, wiping her hands and removing her apron, and one or two waiters pick up a *guitarra Portuguessa* (actually something more like a 12-stringed lute than a conventional acoustic guitar) does the fado begin. Even in such intimate settings such as these, the performances are highly staged affairs. The singer, all in black, stands in front of the instrumentalist; movement is confined mostly to arms and the most vivid expressions of the face. (Female

35

fadistas often wear shawls that, when waved about a bit, add to the dramatic tenor.) The fadista isn't necessarily a female singer, although it just so happens that many of the most legendary ones are. Listeners, especially those who appreciate the subtleties and nuances of fado, sigh wistfully at certain turns of phrase, flourishes and pauses. When really moved, they'll bang the tables and shout, approvingly, 'Fadista!'

La saudade

But if the song doesn't have *la saudade*, it ain't got nothing (see box **Longing**). *Saudade* is – like the *duende* found over the border in Spain – one of those untranslatable words, but its amplified meaning is at the very heart of the successful fado song. *Saudade* is sometimes rendered in English as 'yearning' or 'longing' (and why not? The theme of fado is inevitably about love and loss), but it is also much more than this. Implicit in the singer's expression (and the audience's experience) of *saudade* is that the listener be carried into the journey to the heart of the music's mournful darkness.

In recent years, there has been an upsurge of international interest in fado and its defining *saudade*. It is safe to say that the genre has crossed over into mainstream recognition. The critical success of Nick Cave's exquisite songs of love poised on the brink of loss; of the *morna* from Cape Verde's 'barefoot diva', the cigar-

Longing

'The famous *saudade* of the Portuguese is a vague and constant desire for something that does not and probably cannot exist, for something other than the present, a turning towards the past or towards the future; not an active discontent or poignant sadness, but an indolent dreaming wistfulness.' ■

Aubrey Bell, *In Portugal* (1912), quoted by Rodney Gallop, 'The Fado: The Portuguese Song of Fate', *The Musical Quarterly*, Vol XIX, issue 2.

Dark sounds

'We all experience within us what the Portuguese call *saudade*, an inexplicable longing, an unnamed and enigmatic yearning of the soul, and it is this feeling that lives in the realms of imagination and inspiration, and is the breeding ground for the sad song, for the love song. *Saudade* is the desire to be transported from darkness into light, to be touched by the hand of that which is not of this world. [...]

'In his brilliant lecture, *The Theory and Function of Duende*, Federico Garcia Lorca attempts to shed some light on the eerie and inexplicable sadness that lives at the heart of certain works of art. "All that has dark sounds has duende," he says, "that mysterious power that everyone feels but no philosopher can explain." Contemporary rock music seems less inclined to have at its soul, restless and quivering, the sadness that Lorca talks about. Excitement, often, anger, sometimes – but true sadness, rarely...' ∎

Nick Cave, from *The Secret Life of the Love Song, The Complete Lyrics 1978-2001* (Penguin, 2001).

smoking Cesária Evora, and the angular charms of the Mozambique-born fadista Mariza Reis Nunes have all played their part in this dissemination. And the Portuguese have reciprocated by generously locating *saudade* in international artists, too.

In Portugal as well, fado is very much undergoing its own resurgence, with new interpreters like Cristina Branco, João Pedro and Ana Moura, and above all, Mariza (known, like one of fado's greatest stars, by her first name alone), leading the way. Yet that a nation should embrace such an avowedly emotional music, one simultaneously so intimate and so existential, is curious, if only because it means that when the great fadista dies, a little piece of Portugal dies with them. For example, when one of fado's greatest exponents, Amália Rodrigues (known simply as Amália) died in 1999 at the age of 79, Antonio Guterre – then prime minister of Portugal – declared three days of national mourning for the artist whose music had spoken to so many listeners, not just at home, but across the world. The funeral was, fittingly, a solemn occasion.

Music on the margins

Amália's coffin was sped on its way to its grave at the National Pantheon by over 100,000 mourners on the streets of Lisbon and an elegant escort of plumed horses and cavalry officers. Amália had been, apostrophed Guterre, the 'voice of Portugal' and something had ended with her.

Fado is not exactly a new music. The word, meaning 'fate', entered the Portuguese lyric books in 1833, and it was certainly in use in (Portuguese-speaking) Brazil, some years before that. There has been much debate over its origins, and claims have been made for influences that range from Spanish and Moorish to African musics. There are persuasive cases to be made for all these claims. Lisbon, an energetic port city serving not only Europe, but looking further afield to the Americas and Africa, especially Portugal's colonies there, was well placed to absorb foreign influences.

Napoleon
When Napoleon's armies invaded Portugal in 1807 the royal family and its 15,000-strong court immediately decamped to Rio de Janeiro, capital of its former colony, Brazil, where the fado, a slow Afro-Brazilian dance accompanied by sentimental lyrics, was in evidence. Other claims to fado's origins are more poetic. 'In my opinion,' wrote musicologist Pinto de Carvalho in his 1903 *Historia do Fado*, 'the fado is of maritime origin, an origin which is confirmed by its rhythm, undulating as the cadenced movements of the wave, regular as the heaving of a ship... or as the beating of waves upon the shore.'[1]

Possibly fado bears, the beating of the waves excepted, an element of all these international nuances, but its principal origin lies in the cadences and the rhythms of Portugal's indigenous folk music. The Portuguese king returned to his throne and a country made safe for royalty in the early 1830s. The history of fado can be traced back to this period in certain districts of the

cities of Lisbon and Coimbra, the ancient university city to the north of the capital, but fado's relationship to power and propriety has always been a checkered one. Ever since the days of Maria Severa (1820-1846), the 19th-century fadista and prostitute of renowned beauty, whose name generally begins all histories of fado, the genre has always been associated with the whiff of scandal, of sexual excess and otherness. This is what the musicologist and Iberian expert Rodney Gallop has to say about the peerless Severa:

'Maria Severa, greatest of all *fadistas*, was the daughter of a woman known as *A Barbuda* (The Bearded Lady) who kept a tavern in Madragoa, the fishwives' quarter of Lisbon. Somewhere about 1840, mother and daughter moved to [another Lisbon neighborhood] the Mouraria and established themselves in the Rua do Caplão, which its unenviable reputation had earned the nickname of Rua Suja ('filthy'). From her mother, Severa learned to sing and dance the *fado*. Her moral upbringing went no further; and, like the [famous sea shanty's] Maid of Amsterdam, she was soon 'mistress of her trade'. Living in the atmosphere which engendered the *fado*, she soon became its most renowned exponent. Her first lover, a man of her own class, was banished to Africa for a *crime passionnel*. Handsome, passionate, violent, in all things immoderate, she attracted the attention of a bull-fighting aristocrat with a taste for low life, the Conde de Vimioso... [...] The tempestuous love-affair between these two, of which the sentimental aspect has blinded the Portuguese to its more sordid side, is still sung in many *fados* and forms the foundation on which [novelist] Julio Dantas has woven a story which, as play, novel

and soundfilm, has won widespread popular-
ity. In this story Severa dies, like Mimi in *La
Bohème*, of consumption. But popular tradi-
tion maintains stoutly, and more appropriately
if less romantically, that the real cause of her
death was a surfeit of pigeon and red wine.'[2]

The bearded lady and her lovely, mellifluously toned
daughter living in a road whose name may have dedi-
cated it to the priesthood, but was in practice recognized
by the nickname of *suja*, filthy – this was a perfect,
carnivalesque setting for so immoderate a music. So
perfect as to almost be a kind of musical archetype.
It is a truism that the *mise en scène* conjured up by
the pungently named Rua Suja, a place where poverty
and unruly sexualities combined with the emotional
opulence of music is a repeatable one. We find it in
Edith Piaf's Paris, in the *rembetika* music of the ports
of old Piraeus, and the tango of Buenos Aires.

Fado followers
The Belgian songwriter Jacques Brel, while by no
means a fadista in the conventional sense, is neverthe-
less a fellow-traveler, conjuring up the deep shades
of fado in such classic songs as 'Amsterdam' and the
devastating 'Ne Me Quitte Pas' ('If You Go Away').
The Canadian songwriter and poet Leonard Cohen is,
in terms of musical temperament, another fadista; so is
the British torch singer Marc Almond.[3]

Today, the onward march of *embourgeoisement* has
tidied up parts of Mouraria and the Rua Suja is now
known as the Largo di Severa: a plaque mounted on
the wall of the relevant house honors the memory of
the little road's famous resident. Severa might have been
born into a dirt-poor poverty, but she ended it as an
aristocrat of the realm of emotions.

The real scandal about Severa was, of course,
rooted in her public notoriety. Her romance with the

Conde de Vimioso appalled and delighted society, both polite and impolite. It was gossiped about in song and in print – all with the effect of making fado and its bohemian milieu quite the thing for the more adventurous visitor to Lisbon. The broken-hearted Severa, who had taken to wearing a black shawl of mourning after being abandoned by Vimioso, died in 1846. She was buried in a common grave in the cemetery of Alto de São João, although her fame lived on, and over the decades was transmuted into the pure gold of the performing genius. Many years later, Catherine, Lady Jackson, was one such titillated visitor to Lisbon, looking for the piquancy of the fado underground. The widow of a British diplomat, Lady Jackson provides useful guidance on how one might recognize a fado

The fado milieu

'According to ethnologist Pais de Brito, the fado emerged in certain Lisbon neighborhoods during the second half of the 19th century. The process was similar to that of the Argentinean tango, the French songs from factory towns, the Brazilian samba, or the rembetika of Athens. In all cases, they are phenomena of industrial or harbor towns in the last century, in social milieux characterized by relative social marginalization. The themes are equally similar: love, jealousy, treason, virility, mother-son relationship, the familiarity of death, the dichotomy between rich and poor, painful experiences from which one wants to escape but which, at the same time, confer identity. Fado had a marginal existence at the beginning; in a second period it was appropriated by higher social classes, following an aesthetic of exoticism, pain and decadence, which was a characteristic attitude of late Romanticism. In a third moment, fado went through a process of folklorization and increasing dependence on the tourist industry. Today, in order to find "true" (ie, non touristic) fado, it is necessary to penetrate semi-clandestine environments, partly due to a liberal and bourgeois stigmatization of its inherent Marialva ethic.' ■

© Miguel Vale de Almeida, from *Marialvismo: A Portuguese Moral Discourse on Masculinity, Social Hierarchy and Nationhood in the Transition to Modernity*, Série Antropológica (occasional papers, number 184). Brasília: Departamento de Antropologia da Universidade de Brasília, 1995.

follower. 'Fadistas wear a peculiar kind of black cap, wide black trousers with close-fitting jacket, and their hair flowing low on the shoulders,' she wrote in her book *Fair Lusitania* (1874). 'They are held in very bad repute, being mostly *vauriens* ["wasters"] of dissolute habits.'

And more endorsements of fado's louche image followed. In his history, Pinto de Carvalho reached a descriptive crescendo, one here recalled by the anthropologist and critic Miguel Vale de Almeida: '[T]he fadista was someone who had attained the "ideal perfection of the ignoble"; he was a "Don Juan of the slums, a Valmont of sloth..."' De Almeida quotes de Carvalho's words nearly a century later, in his *Marialvismo* paper presented to a Brazilian conference in 1995.[4] The *marialvismo* that de Almeida mentions is significant. By the end of the 19th century, fado was for the most part associated with carousing hoorays who liked nothing better after a bullfight than strong drink and sad songs. These men, aristocrats, young bloods and playboys, were defined by this *marialvismo* – a quality named after the Marquis de Marialva, the original well-born hellraiser. Marked by an unreconstructed chauvinism that was expressed in their nationalist tendencies as much as sexual politics, it was these new fado enthusiasts who would, by the 1930s, be the harbingers of a more serious political reality – and one that would taint the music for years to come.

Coimbra's version

In Coimbra, it was a different story. Here, there were no Don Juans or Valmonts with whom to keep dangerous company. In this town, fado was renowned for its measured tones and a vocabulary in keeping with that place's academic setting. As Rodney Gallop succinctly puts it in his 1930s account, '[Fado in Coimbra] is no longer the song of the common people. It has become the property of the students who wander along the

green banks of the Mondego, among the poplars of the [Choupal], dreamily singing to their silvery guitars [....] At Coimbra the fado seems to be divorced from everyday realities and cares and to express a vague romantic yearning which is in keeping with the atmosphere of the ancient university city. It is the song of those who still retain and cherish their illusions, not of those who have irretrievably lost them.'

But in addition, Coimbra offered something more. This was the fado that delighted in the virtuouso world of the *guitarradas*. These colorful, instrumental pieces, normally performed on a pair of Spanish guitars, in many ways offered a game of wit. Each player would improvise around central motifs. The best guitarrada was a piece of music as conversation, the dialog flowing back and forth, the ideas suggested by one player over a few bars caught up and mulled over by the second player who would then, with a flourish, offer his own riposte to his companion. The great Coimbra guitarradas of the 1920s and 1930s included Artur Paredes and Jose Joaoquim Cavalheiro, musicians who lived long enough to submit their music to recording studios and crackly 78 rpm records. Coimbra's guitar tradition was not bought at the expense of its vocalists and lyricists, however. A trio of singing doctors – Antonio Menano, Lucos Junot and Edmundo de Bettencourt – active between the world wars, is generally regarded as the apotheosis of the Coimbra tradition.

Fado in flux

Gallop's description is a valuable witness to the changing nature of fado across Portugal. He was witnessing performances and gathering research material at a point in history where the very nature of fado – its freedom of expression, its individual core of suffering, its status as the country's urban folk song – was under threat.

While it is simple to characterize the lyrics of fado

as being about individual suffering, the reality was more complex. By the end of the 19th century, fado was already a big subject. On the one hand, fado was taken up by the roaring boys, sowing their oats before returning to become the pillars of establishment; on the other hand, it was fast becoming politicized. The working population with which its origins were most associated was not immune to shifting economic pressures. Growing industrialization and corporate growth were having a deleterious effect on a people already impoverished. Anarchist and socialist topics became popular themes for many fados. 'You had fados talking about Kropotkin, Bakunin, Marx – and even Lenin later on,' fado historian Rui Viera Nery told *Songlines* editor and film director Simon Broughton, in his informative documentary, *Mariza and the Story of Fado* for the BBC in 2007.[5] And writing in the *New Statesman* the same year, Broughton quotes a socialist fado dating back to 1900 which is to the point as regards its ideological bent: '*1 May!/ Forward! Forward!/ O soldiers of freedom!/ Forward and destroy / National borders and property.*'[6]

Portugal's New State
In the years following the end of the First World War, which Portugal had entered in 1916 as a British ally, the level of unrest within the country had increased. There was a period of civil war in 1918 as monarchists, republicans and civil militias fought on the streets. One fado, written by a nameless anarchist in the early 1920s and cited by Broughton, offered a solution to calm the troubled times and ameliorate the lot of the workers: '*The world shall behold/ The poor free from oppression/ Smashing the butchers/ Of the ruling bourgeoisie.*'

Meanwhile, political tensions increased. Political assassinations were not uncommon. A military coup in 1926 resulted in the second republic, which was later to become the authoritarian, religiously conservative

Estado Novo [New State], led by the military dictator Antonio de Oliveira Salazar in 1933. Like Germany and Italy, Portugal had become a dangerous place in which to express dissent.

By the time Amália Rodrigues died, Salazar's regime was recent history. Yet Prime Minister Guterre's identification of the singer as the voice of the nation (mentioned earlier), is itself telling. He may have been speaking nearly three decades after the death of Salazar in 1970 and 15 years after the end of the Estado Novo (thanks to another military coup, this time a leftwing orientated one, referred to as the Carnation Revolution). It was also at the point where his country had evolved into a full European democracy – Portugal had joined the European Union in 1986 – but the memory of the New State (which staggered on under the leadership of Marcelo Caetano before being overthrown in 1974), still lingered.

The Estado Novo had not been a fascist regime in the generally accepted sense (it lacked, for example, the personality cults present with Hitler and Mussolini), but Salazar's one-party rule certainly constituted an ultra-rightwing, authoritarian regime, one that reinforced unreconstructed Catholic and nationalist values. An oppressive level of state censorship and an active secret police (political dissenters were exiled or imprisoned) were features of daily life. The control of all aspects of culture and social life were central to the regime.

Airbrushed fado

Fado's lyrics were censored, sometimes airbrushed, and writers were urged towards the promotion of anodyne words. But with fado too popular to be alto-gether suppressed, Salazar took the step of effectively annexing it. Musicians were corralled into *ranchos folclóricos*, folky ensembles, where they could be closely watched and controlled. As academic Kimberly DaCosta Holton notes in her book *Performing*

Music on the margins

Folklore, the authoritarian imperative to 'control' folklore, and with it the stories, music and dance pertaining to nationhood, is something familiar to other authoritarian regimes, Mussolini-era Italy, Nazi Germany and the Soviet Union under Stalin included.[7] One could add many other regrettable examples. What is the wellspring of folk tradition? Arguably it is its mutability. Without the chance of change, of responsiveness to new circumstances, tradition becomes an ossified routine, a performance that increases in meaninglessness as time goes on. Salazar's *ranchos folclóricos* represented the fantasy of a static culture; they were examples of what the historian Eric Hobsbawm has identified as 'invented tradition'.[8]

Amália Rodrigues

It was in this stifled atmosphere that Amália Rodrigues, who made her professional debut as a fadista in 1939 at a hip fado club called the Retiro de Severa, had much of her career. How was she able to transcend the cultural politics of her historical period? Possibly because her voice and ornamented style of singing was one that appealed to both the popular audience as well as a more refined one. Certainly her international status, as one of Portugal's biggest exports after cod liver oil, helped. But more significantly, it was the fact that fado's lyrics could often be quite vague. Fado's favorite theme – of loss and longing – was also sensitive to an allegorical listening. As Amália sang in 'Tudo isto á Fado' ('All this Is Fado'), *'Fado is everything I say/ And everything I cannot say'*.

Following 1974's revolution and the final collapse of the Estado Novo, Amália was accused of being in the pay of Salazar's secret police. It was known that she had written poems dedicated to the old dictator (and she once confessed to having a crush on him), but the charge that she had been a spy was wrong. It later turned out that, far from being a stooge of the Salazar

regime, Amália had provided clandestine funding to communists and anti-fascist organizations during the years of the Estado Novo. Moreover, she could never have been unaware of the fado's leftwing tradition. 'She stayed one step ahead of the censors by singing slyly subversive songs with lyrics by leftwing poets such as Ary dos Santos, Manuel Alegre, Alexandre O'Neill and David Mourao Ferreira,' notes writer John Lewis.[9]

Undeniably, Amália was a unique figure, someone who was capable of transcending politics, even in a country as fractured as dictatorial Portugal. She had an appeal that crossed boundaries and she was savvy enough to know this strength. The striking Mariza herself pays tribute to her in Simon Broughton's documentary. 'Amália was the first fado singer who had the vision of crossing frontiers,' she states, referring to Rodrigues' capacity to mean something to anyone who might listen.

Fading fado

And yet, despite Amália's popularity, by the mid-1970s, fado was in a bad way, with its future path unclear. Portugal emerged from its decades of dictatorship wondering about its modern identity. It was a period marked by bitter independence wars in the country's colonies of Angola, Mozambique and Guinea. Debates about the shape of a new Portuguese identity had much material: the legacy of Salazar; the new, and hitherto unknown post-imperial status; as well as levels of rural and urban poverty that would soon lead to mass emigration of young workers, in particular to the US and Britain. In 1975, Portugal's gross domestic product per capita was just over $6,000 – $2,000 less even than Greece, long one of Europe's poorer nations. By way of contrast, that of the US was $19,364.[10]

It was inevitable that a Portugal in such flux would react against the old order and all its accoutrements, fado included. The stage-managed activity of *ranchos*

Music on the margins

folclóricos meant that fado – in as much as it was a national song – was seen as tainted by its association with fascism. Fado was, at best, something that had passed into the realms of kitsch. For the next 20 years, the music went into a state of, if not decline, then at least suspension.

Singing a new song

In fact, this proved to be the prelude to fado's great renaissance. The hiatus following the Carnation Revolution was not a complete one: musicians such as Luis Cilia, Sergio Godinho and José Alfonso stepped into the breach with what came to be called *nova canção* – new song. *Nova canção* had – and has – a wider remit than fado: regional folk musics and instruments such as bagpipes, scallop shells, pipes and drums, acapella vocals and dialects could feature in the songs. Formed in 1996, Galandum Galundaina is a group from north-east Portugal that celebrates the very minority Miranda language of the region.

Markedly, the musicians of *nova canção* were, for the first time in years, to express overt political sentiments. Most famous among these is the Brigada Victor Jara, a group formed in Coimbra in 1975 and named after the Chilean socialist songwriter who had been killed three years before in an uprising led by another military dictator, Augusto Pinochet. Jara, much interested in Chilean folklore and music, had been at the heart of his country's *nueva canción* – new song – movement and it was his lead that the Brigada followed. The Portuguese band has achieved an international following with its fusion of leftwing anthems, traditional music and boundless energy.

The development of *nova canção* had the effect of giving fado the space to develop its new voice. It has done so by offering not one vision of fado, but a plurality of them. All the musicians involved are ones who came of age years after the fall of Salazar.

From Lisbon, Madredeus, a band formed in 1985 and named after a local tram stop, had a line-up that offered a combination between classical, pop, cabaret and folk elements. Local fame gave way to international success and multi-million album sales after they were featured in Wim Wenders' film, *Lisbon Story* in 1994. Cristina Branco, born in 1972, found herself attracted to fado following an earlier immersion in blues, jazz and folk; even now, her fado is not unafraid to incorporate new elements, notably electronics, into the mix. Mísia, originally from Oporto and far from Lisbon's fado houses, imports Latin rhythms, specifically hints of tango, into her multilingual fado, along with violins and other instruments. Ana Moura, born in 1980 and one of the leading lights of new fado, has turned towards the more traditional aspects of the music, including that of improvisation. And men are not left out of the equation either: singer João Pedro and guitarist Antonio Chainho are definitely ones to watch.

Mozambique-born Mariza

However, in terms of fado since the late 1990s, it is Mariza Reis Nunes who has come to personify the genre. Certainly, she is an elegant ambassador for the music: she is a consummate performer, blessed with great presence and even greater voice. And like Amália before her, she is serious about invigorating the whole corpus of fado by collaborating with new composers, lyricists and poets, such as Pedro Campos. Her 2008 album, *Terra*, with its turns towards jazz and flamenco, is one such example. Mariza is very much her own invention – 'I am not the new Amália Rodrigues,' she declares in Simon Broughton's fado film, 'or the new Edith Piaf. To each time its own.'

Nevertheless, Mariza is a performer with an instinctive feel for her music and its origins. Catch her on stage and there will almost always be a moment when

the young singer climbs down from the stage, throws down her mike and belts out the songs for all she is worth. Yes, these moments are scripted dramas, but they do much to highlight Mariza's sheer power of delivery as much as demonstrate the street-smart earthiness of a good fado.

Never a closed system, fado has always been a porous medium – one that influences as much as it is influenced. Fado is not, as far as its formation is concerned, a unique music. There are multiple examples of popular musics that have developed in locations where indigenous musics rub shoulders with outside influences, where the developing new sound becomes as much a signifier for a liminal state of being as of its listeners themselves. The heady mix of an urban population whose location produces a creative contact with itinerants is something replicated in many other places. Buenos Aires and tango; Cape Verde and *morna*, Havana and the African rumba – all three musics have grown up in a similar way and, just as fado does, have historical associations with depravity (tango), poverty (morna) and sexuality (rumba).

Greece and *Rembetika*

Rembetika (sometimes transliterated as *rebétika*) can boast all three associations, and add a fourth one to boot: criminality. Fado may have got the expression of exquisite sadness down to a fine art, but Greek rembetika can answer its every tear, its every sigh, with a whiff of hashish burning on the *narghilé* (water pipe) in the local *téke* (hash den) and a kind of 'Who cares?' shrug. Rembetika, even its earliest shellac recordings, all sparsely instrumented and rasping vocals, claims a richly flavored realm.

A brief look at some of the song titles gives even the casual visitor to all things rembetika a good idea: 'I'm a Junkie'; 'Prison is a School'; 'While We Were Smoking Dope One Night'; 'In Marigo's Hash Den'

and a vast array of songs dedicated to getting hash, grading hash, getting stoned and running out of hash. Now and then other powdered drugs – *preza* refers to cocaine or heroin – filter into the songwriters' vocabularies, but it is really the soporific glories of cannabis that float the rembetika boat. It has been suggested that one of the reasons why rembetika never became a political force, despite its grassroots appeal, was because its main adherents were too stoned to organize anything. One of the most famous songs, written by Yiorgos Batis and recorded in 1935 by Stratos 'the lazy' Payioumdzis, spells it out:

'Secretly in a boat I went
And came out at Thrakou's cave.
I saw three men stoned on hashish
Stretched out on the sand.

'It was Batis and Artemis
And Stratos the lazy one.
Hey, you, Stratos, yes, you, Stratos,
Fix us a fine narghilé!'[11]

The origins of the word rembetika come from the Turkish word *rembet* – 'of the gutter; outlaw', according to Ed Emery of the cultural organization the Institute of Rebetology. Rembet is also a word with an etymological proximity to the Serbian word, *rebenok* or 'rebel' – which signifies the territory of its claim.[12] These shifting definitions in a spread of linked languages are significant. they are the linguistic evidence of a shared historical intermingling.

The Turkish Ottoman Empire, which finally collapsed after the end of the First World War in 1918, was one which had once extended westwards from Istanbul far into Europe and its subject populations included a multiplicity of ethnic and religious groups, Jews, Christians and Muslims among them. Although the

independent Greek state was founded in 1829 (following a revolution against Turkish rule, begun eight years before), the extent to which a full cultural separation from all things Turkish was ever achieved is debatable. This has led to much angst among some Greeks. Writer, academic and all-round enthusiast Gail Holst, whose *Road to Rembetika* – a book so hugely influential that it has more or less defined the romance of rembetika for the English-speaking world – writes 'that few subjects have aroused such controversy in Greek cultural life as the rembetika songs', with one of the charges leveled against it being its 'oriental' nature:

> 'We would have to say that like many other phenomena in this small and proud nation, the songs were admired to the extent that they were seen as Greek, and despised when they were considered foreign. References to drugs and the underworld were viewed by the opponents of the rembetika as part of the Ottoman legacy, but few critics knew or cared that many of the songs were simply Turkish tunes with Greek words.'[13]

Greece's blues?

It is now a prevailing shorthand to refer to rembetika as Greece's urban version of the American blues, in the same way that fado has become Portugal's blues. It is not an entirely accurate elision – the experience of the Greek poor was not and is not that of America's black sharecroppers hammering out their proto-blues in the wilderness of the Mississippi Delta, in terms of either displacement or brutalization.

But it is a telling process. Rembetika, for all its influences – its modal origins; its Middle Eastern-originated passages of improvisation or *taximia*; its mid-song cries of *'Amané!'* – Mercy! – began as a genuine urban song borne out of adversity. It addressed the perennial problems of those who were

powerless, at least in a social, structural sense and it celebrated their survival in adversity.

Rembetika has rich themes: drugs, jail, the travails of love and, on numerous occasions, death. In one *rembetiko*, Panayiotis Toundas' 'Conversation with Death' (1936), the singer asks Charon, the mythological ferryman of the dead in Greek legend, to take some hash to a dead comrade in order to sweeten his afterlife in Hades. In another song, altogether moodier and slower, the great Stratos Payioumdzis addresses Death directly: '*Open up, Death, I am knocking/Let me enter and clean up/ The place which forever more/ Will be my eternal home.*'

There are songs that are about more than simply surviving a jail term; there are songs that fantasize about a capacity to command even Death himself. That said, the songs about being beaten up by the police and about insults were nearer the mark. 'You called me a bum,' begins one famous *zebekiko* dance song by Manos Hadjidakis.

Cloudy Sunday

For a sadness that transcends language, go to 'Cloudy Sunday' by the prolific songwriter and great bouzouki

'Conversations in Jail'

'One night, boys, they laid a trap for us
And surrounded us inside Maounieri's place.
Some double-crossed fingered the joint
And a dozen cops raided us.

They beat us with twelve clubs while we were completely stoned.
We pulled three knives but they did us no good.
We got beaten so hard – Christ! It's a wonder they didn't kill us,
And every one of us got loaded with four years in the pen.' ∎

Zembekiko, usually ascribed to Panayiotis Toundas, quoted by Gail Holst, *Road to Rembetika*.

player Vassilis Tsitsanis. This was written at the time of Greece's occupation by Germany during the Second World War and voiced by the throaty and incomparable Sotiria ('Salvation') Bellou, an Orthodox priest's daughter whose long career took in lesbian affairs, prison terms, beatings from German soldiers, leftwing political activities and the admiration of at least one Greek prime minister, Andreas Papandreou – who ensured that, after her death in 1997, she would be buried at state expense amongst the great and the good in Athens.

Bellou herself has passed into rembetika legend, joined by so many others – Markos Vamvakaris, Batis, Anestos 'Artemis' Delias; the women singers Roza Eskenazi, Rita Abatzi, Marika Ninou, Marika Papagika. There are many more, although any study of rembetika that ignored these musicians would be worth little. Many of the musicians named above had careers that took them far from the bars and clubs of Piraeus. Papagika, for example, was born on the Greek island of Kos, then lived in Alexandria, where she began singing and recording for Egypt's sizeable Greek community before emigrating to the US. There she and her husband ran a popular club – catering for Greek expats – on New York's West 34th Street. Eskenazi was born into a Sephardic Jewish family in Constantinople around the turn of the 20th century (they later moved to Thessalonica) before being discovered singing and dancing in a nightclub called Tsitsifies ('Pals') near Piraeus, by the famous rembetika composer Panayiotas Toundas. Eskenazi, who sang in an array of languages that so well reflects the Mediterranean populations – Turkish, Greek, Armenian, Ladino, Italian and Arabic – had a prolific career and the swing of her voice and turn of phrase is seductive even now.

Hash dens of Piraeus

But back in Greece, around the port of Piraeus where rembetika developed at the turn of the 20th century, the

music was anything but sanitized by widespread appeal. Evolving in the bars and *tekédhes* (hash dens), rembetika was simultaneously a music that was singular to its milieu of a growing urban class and hybrid in terms of its development and influences. Its singularity lay in its unique urban voice: the early Piraeus songs are peopled with real characters starring in their own show.

Gail Holst conjures up a memorable scene of a typical *téke* in Piraeus around the 1920s. She imagines people such as Marino the Moustache and Crazy Nick, the latter a shady character who had written several rembetika songs and was alleged to have killed at least once. There would be almond wood, or perhaps walnut and thyme, on the fire. The *rembetes* – who could be the musicians as well as their listeners – would tune up their favorite *baglamas* or bouzoukis.

Holst evokes a visit from the mighty Markos Vamvakaris, the barely schooled newspaper man (and dope dealer) from the Aegean island of Syros and the bouzouki-player whose name and gait is synonymous with the culture of rembetika today. Markos, so the legend goes, stowed himself a passage to Piraeus in about 1920, after a short spell in prison, alongside his entire family, for his hash dealing. On arrival, he got himself a job as a stevedore, then a slaughterhouse man, in the docks and, at some of the port's numerous tekédhes, he heard the bouzouki. Maybe Markos didn't actually vow to cut off his hand if he didn't learn to play the bouzouki in six months – the story is too much of a generic folktale, but it is a colorful example of the mythmaking process surrounding rembetika and its edgy adherents.[14] Markos, like Amália and a handful of other great rembetika musicians, has passed into a realm where, such is their fame, a surname is unnecessary.

And it was here in the most basic bar that rembetika was performed: the little, lute-like baglamas and bouzoukis played, and the voices rasped into the night

sky. Other relatively upmarket venues, the so-called *cafés aman*, might offer ensembles with violins, *santouris* (hammer dulcimers), and women singing and dancing, but it was in the dirt-poor tekédhes in which this thing called rembetika was distilled from its multiple origins and so began life. It was essentially a development of an oral tradition, one that prized improvisation and which was an urban response to an urban landscape.

More than folksong

But rembetika is not simply the folksong of an entire urban poor, but a very particular subset of them: the men (and invariably they were men) referred to as *manges* and *rembetes*. So who were they? To take the rembetes (singular, *rembetis*) first: these were the rembetika enthusiasts, the fans, who to some extent identified themselves with the rembetika lifestyle and subculture. From the beginnings in the Piraeus hash dens, the rembetes would meet to drink a little, smoke a little, pass the time of day. There were other clientele, too. These included the dandified *koutsava-kidhes* who, according to James Sclavunos – a second-generation Greek-American percussionist, Nick Cave associate and rembetika fan – 'usually exhibited very stylized bearing and mannerisms'.[15] Holst further identifies *vladmidhes*, 'tough guys', and *tsiftes*, groups of male friends.

The lads

But, rembetes aside, many of these terms have been overtaken by the manges, a bunch who were an alto-gether more serious affair. Much has been written on the manges, the men who frequented the portside tekédhes. The manges – 'lads', a word that still has some currency in modern Greek – who lived the life of the rembetika-loving, dope-smoking, ducking and diving make-do existence, were men who trod a path

parallel – either by choice or necessity – to politer society. The manges were, explains Sclavunos, 'street guys, tough guys – guys who were savvy... they may have directly or indirectly associated with the criminal class, but the manges were men who bore a social prejudice inflicted on them.'

By all accounts, they constituted a culture that still remains very much embedded in the early rembetika. The typical *mangas* was dressy: he favored a 'republican' – a two-piece suit – worn with a cloth cap, vest and perhaps spats. He might wear a *zonari*, a sash worn around the middle, rather like a more flamboyant cummerbund. The zonari, Sclavunos suggests, probably originated among the *zeybek* warriors from Asia Minor in the time of the Ottoman Empire. It was useful for stashing essential items – a knife, a baglama and other small objects. And it was from the zeybek dance, one that emulates the swooping of a hawk, that the manges got their *zeibekiko* dance: a male dance that had to be performed alone. Dancing was hugely important: it was reflective, considered, a self-owned thing. Even decades after rembetika had gone mainstream, Holst is able to offer a compelling account of one man's communion with the music in mid-60s Athens in this description of a zeibekiko dancer:

'Young men would come into a taverna, feed a handful of coins into the juke box and begin to dance, sometimes together, more often alone. The solo dance was unlike any dancing I'd ever seen – not exuberant, not being done for the joy of movement, not even sensual. It reminded me of a Quaker meeting, where only if the spirit moves does a man speak. The music would begin, the rhythm insistent, the voice harsh and metallic, and the dancer would rise as if compelled to make his statement. Eyes half-closed, in trance-like absorption, cigarette

hanging from his lips, arms outstretched as if to keep his balance, he would begin to slowly circle. As the dance progressed, the movements would become more complex; there would be sudden feats of agility, swoops to the ground, leaps and twists, but the dancer seemed always to be feeling his way, searching for something, unsteady on his feet. The dance took place in public, people were watching it, and yet it appeared to be a private, introspective experience for the dancer... It was as if the dance served as a sort of catharsis for the dancer, after which he sat down at his table and continued eating and drinking with renewed appetite.'[16]

This is serious dancing, but even then it was possible to be more serious still. Sclavunos, who grew up in Brooklyn, tells of a self-mutilation dance that expressed toughness in an overt way. The dancer who really wanted to signal his 'don't-mess-with-me' attitude might drive a dagger into his heel; the deeper the wound, the bigger mangas you were. The slight limp that resulted would indicate the battle-hardened status of the man.

Turkish influence

If this is a fanciful snapshot of early rembetika, it is one that is unavoidably seen through the lens of the genre's own capacity to mythologize itself. As soon as rembetika began to move, so it changed. In one important aspect, this change was forced upon it. In 1922, the Turkish army overran the Greek-administered city of Smyrna (now Izmir) on its western seaboard. The Turkish advance was, in itself, a response to the Greek government's exercise of its long-held *megéli idéa* – the 'great idea' to bring large chunks of the ancient Byzantine Empire into the new Greece.

The Greek campaign was disastrous to the extent

that what happened next is expressed simply – even now – as the 'Asia Minor Catastrophe'. The epithet encompasses actually far more than just the terrible events of Smyrna. In the years preceding 1923, the Turks had also prosecuted massacres against Armenian, Assyrian, Anatolian populations and Pontic Greeks. Even now, it is far from easy in modern Turkey to raise the subjects of these genocides.

The Turks, resurgent under their nationalist general Mustafa Kemal (later Atatürk, 'Father of the Turks'), drove Smyrna's Greek and Armenian population into the sea. Some 150,000 were massacred, the ancient city burnt to the ground. The following year, a vast population exchange was set in chain. Greeks were expelled from Turkish territories. In turn, Greek-speaking Turks living in Greece were shuttled over to Turkey. More than two million people were involved. There are many reliable accounts of the violence with which this ethnic cleansing was accompanied. The exchange was a blunt and brutal instrument that sought the impossible: geographically and histori-cally, culturally and ethnically, the populations of Greece and western Turkey had shared a symbiotic relationship. The Catastrophe was not the beginning of the enmity that characterizes Greco-Turkish rela-tions even now, but it plays a large role in the levels of tension and rancor.

Impact on the music

The effect that the Catastrophe had on rembetika was soon felt. Refugees, many destitute, flooded into Greece via Piraeus. Economic conditions worsened as Athens absorbed those who didn't leave Greece altogether – many refugees went to Australia, begin-ning an emigration that has helped establish a thriving community there. But the refugees also brought to the tekédhes a more accomplished style of music. Violins, pianos, accordions, santouris and zithers were added

to the conventional instrumentation. Women singers such as Rita Abatzi and Marika Politissa made their names. Slowly, the repertoire broadened, and so did its audience.

But this didn't happen overnight. There was still time for Markos' 1935 'Alaniaris'[17], very much a pure téke song, to make its mark:

> 'I'm a wide boy,
> Wandering the streets,
> So stoned I don't
> Recognize anyone I meet...'

But that the band that made it – Markos, accompanied by Stratos and his great collaborators, Artemis and Batis, the latter two both refugees from Asia Minor – was indication of how change was in the air.

Changing times

By the late 1930s, much of the rembetika that was played in the clubs had been sanitized by a widening appeal; the songs were leaving their low-life themes to embrace more generic topics. There was also the growing popularity of the *tetrachordo* (four-stringed) bouzouki which had four pairs of strings as opposed to the *trichordo* (three-stringed) three-paired. The tetrachordo has a fuller sound, and its tuning makes transpositions from guitars and conventional lutes easier.

A period of dictatorship (1936-41) under the nationalist general, Ioannis Metaxas, saw crackdowns against the rembetika clubs: many tekédhes were closed and censorship was imposed. Occupation by Italian and German troops during the Second World War was the cause of much privation, and although some rembetika was written during that unhappy period (including Mihailis Yenitsaris' 'The Jumper' from about 1942: *'I'll jump, I'll jump/ I'll take their*

jerry-cans'), musicians had to watch their step.[18] The rembetes got short shrift from the left wing, too. The communists took a dim view of dope-smoking and their culturally-suspect themes and preoccupations. Markos, when joining up with the leftwing Greek People's Liberation Army in 1943, was warned against singing his own material 'lest it corrupt the heroic proletariat'.[19]

By the 1940s, it seemed that the ascendancy of the so-called popular song style (*laïko traghoudi*) was unstoppable. Initiated by composer and player Vassilis Tsitsanis – author of over 500 rembetikas and 'discoverer' of Sotiria Bellou – laïko very much served a purpose to lift rembetika out of its original context. *Laïko traghoudi* was, much more so than earlier rembetika, a porous form, borrowing from musical conventions of Western European and quite different from regional (*dhimotiki*) traditions. The end of hostilities against the Axis Powers in 1945 brought no peace for Greece, which was quickly swallowed up in a bitter civil war that lasted until 1949. It is from this period that the first recording of Tsitsanis' 'Cloudy Sunday' in 1948, mentioned earlier, dates.

Out of Greece

Help for rembetika came from an unexpected source. Manos Hadjidakis, one of Greece's up and coming classical composers, championed it as a truly popular voice of his country's song. Look past its grimy origins, he said, and Greeks would see a vigorous art form that was uniquely theirs. Hadjidakis' support extended further: his *Six Folklore Paintings* (1951), written for piano, took some rembetika tunes as the starting point and, in doing so, reframed the gritty folk for a new generation.

Rembetika was also reaching international, non-Greek audiences. Hadjidakis' soundtrack for *Never on Sunday* (1960) brought more admirers to rembetika.

Music on the margins

The film is a love story about a Piraeus prostitute and a visiting American scholar, with the delightful Melina Mercouri in the lead role (21 years later she became the first female minister for culture in the Greek government). The film was a light-hearted number, but one that clearly loved rembetika. The writer, director and male lead Jules Dassin set numerous scenes in one fictionalized little portside bar, where Greek men danced (alone – never, as one incident in the film makes clear, for the entertainment of others), slugged down ouzo and listened to the band.

Never on Sunday picked up numerous awards and Hadjidakis' soundtrack collected an Oscar in 1961. But it was Mikos Theodorakis, another clas-

Oh, baby!

The most famous example of rembetika that has made the journey into mainstream popular music has to be 'Miserlou', the 1962 Dick Dale instrumental that boasted blisteringly fast arpeggios for electric guitar and was used in the opening sequences of Quentin Tarantino's 1994 film, *Pulp Fiction*. 'Misirlou' (it was Dale who changed the spelling) started life at a far more sedate pace in Athens in 1927, when Michalis Patrinos wrote the rembetika tune for zeibekiko dancers. The tune, one whose lyrics mixed Greek with Arabic exclamations of *'Ya habibi!'* – 'Oh, baby!' – was imported to the United States by waves of immigrants from Greece, Turkey and the Levant, Dale's Lebanese father among them. A war-time jazz version by Nick Roubanis – who claimed song-writing credits for himself – was a hit with dance bands, but it was at the East Coast nightclubs catering to the Greek and Levantine diaspora that the tune began its metamorphosis. Since Dale, 'Misirlou' – to keep its original transliteration – has undergone yet further transformations. The Beach Boys, Connie Francis and Agent Orange have sung it; there are klezmer versions and easy-listening versions and Ladino versions. The Kronos Quartet, one of the world's leading contemporary classical string ensembles, recorded an improvised version entitled 'Misirlou Twist' on their album *Caravan*. And still the song goes on. French-Algerian musician Rachid Taha has done an Arabic drum 'n' bass version; 'Pump It', a single from Los Angeles hip-hoppers the Black-Eyed Peas was well informed by 'Misirlou'; and Puerto-Rican reggaeton singer Franco 'El Gorilla' used it as a basis for 'Dame Un Kiss' The title, incidentally, translates as 'Egyptian Girl'. ∎

sically trained composer (and later responsible for the soundtrack to the 1965 film *Zorba the Greek*), who brought rembetika right out of Greece and into the international cinema, following Hadjidakis' lead. Suddenly, rembetika was the order of the day: in answer to the phenomenon of American rock and roll, the bouzouki went electric. The music became a leitmotif for an idea of Greece itself and the twanging bouzouki became the soundtrack to anything Greek: restaurants, films, commercials. It was the beginning of one of rembetika's most sustained incursions into mainstream music.

It is impossible to talk about contemporary rembetes. The music still exists, mutating, as it should. Yiorgis Dalaras, now a stately 60-something year old, remains a significant power in rembetika. Dalaras, whose father was a rembetis from Piraeus, scored a platinum-selling album with *Rembetiko* (EMI, 1975). The children of the children of successive waves of Greek emigration are busy, too. The listings columns for gigs all over the world have rembetika bands. Even the Vanity Set, the band that James Sclavunos plays in when he's not elsewhere with Nick Cave's Bad Seeds or Grinderman, and which includes other American musicians of Greek origin, has a quick dabble in rembetika-inspired bouzouki music.

Rembetika today
But what does it mean to play rembetika now? The context that gave birth to it no longer exists, even if the mood does. And, arguably, this mood has – by virtue of the modernization of Greece – to be located elsewhere. Liminal or 'in-between' musics now might be anything: Tuareg blues; arthouse electronica; psychedelic Finnish folk. And yet there is enormous appetite for this dignified, grainy music. Record collectors do valuable archive work to save and digitize old recordings. There are numerous rembetika compilations to be recom-

mended, some even with half-decent sleeve notes and translations into English. The rembetika that appear in the wide-ranging work of Diamanda Galás – there are two on her *Defixiones, Will and Testament, Orders from the Dead* (Mute, 2003), a song cycle of profound commemoration – are nothing less than spirits that rise up from the dead.

This chapter started discussing liminal music: its subject was two examples of music that thrived on ambiguity – musical, moral, sexual; music that grew out of social structures so caught in a process of unimaginable change that it was somehow able to harness this energy of change to its own ends. Fado, rembetika and tango, too, are all forms that benefit from this slippage. It is the very lack of any confinement to structure that provides its root strength.

In 1936 the German critic and philosopher Walter Benjamin famously wrote about the 'aura' of a work of art in what he identified as the 'age of mechanical reproduction'. The aura, a kind of collective projection of admiration towards that which is unique in the sense that it cannot be replicated, describes more than an acknowledgement of awe. It is shot through with the desire to find something that is real, that is authentic, that is the *fons et origo* of something. Benjamin was dead before he could experience the speed of the 21st century, its proliferation of forms, the very loss, in the process of digital reproduction, of the object itself. All of which is not to say that Amália, Markos and so many more besides are not worthy of attention and delight; it is more to say that in hearing them now we also mourn them.

This relationship between music and death, or rather how music can carry people to death in the service of a malevolence, is the subject of the next chapter.

1 Quoted by Rodney Gallop, 'The Fado: The Portuguese Song of Fate', *The Musical Quarterly*, Vol XIX, issue 2, pp 199-213, 1933. **2** Gallop, ibid. **3** A torch song typically expresses unrequited love. It is more a subject matter than a

distinct genre. **4** Miguel Vale de Almeida, from *Marialvismo: A Portuguese Moral Discourse on Masculinity, Social Hierarchy and Nationhood in the Transition to Modernity*, Série Antropológica (occasional papers, number 184). Brasília: Departamento de Antropologia da Universidade de Brasília, 1995. The Vicomte de Valmont is the dissolute aristocratic anti-hero in Pierre Choderlos de Laclos's *Les Liaisons dangereuses* (1782), an epistolary novel published, to a thrillingly scandalized reception, a few years before the French Revolution saw off many of that kingdom's real (as opposed to fictional) nobles. Laclos's book has been a bestseller for centuries. **5** A DVD of Simon Broughton's 60-minute *Mariza and the Story of Fado* (2007) is one of two films included in *Mariza*, a boxed set of the singer's three CDs to date and issued by EMI Portugal in 2008. A caveat: as the DVD was produced for the Portuguese market, not all the dialog receives English-language subtitles. This issue may be addressed in forthcoming editions of the boxed set. The second DVD in the box is of Mariza's *Concerto em Lisboa* (2006), a performance that has also been released separately by EMI Portugal. Sadly, Rui Viera Nery's book *Para uma História do Fado (Towards a History of Fado)* has not yet been translated from Portuguese into other languages. **6** Simon Broughton, 'Secret History', *New Statesman*, 1 October 2007. www.newstatesman.com/music/2007/10/portuguese-fado-lisbon-regime. **7** Kimberly DaCosta Holton, *Performing Folklore: Ranchos Folklóricos from Lisbon to Newark*, Indiana University Press (2005). More generally, the tension between all nationalisms on the one hand and the promotion of folk practices on the other is a fascinating subject for discussion. See also Johann Herder's work on the character of national culture. **8** '"Invented tradition" is taken to mean a set of practices, normally governed by overtly or tacitly accepted rules and of a ritual or symbolic nature, which seek to inculcate certain values and norms of behavior by repetition, which automatically implies continuity with the past. In fact, where possible, they normally attempt to establish continuity with a suitable historic past... However, insofar as there is such reference to a historic past, the peculiarity of "invented" traditions is that the continuity with it is largely fictitious. In short, they are responses to novel situations which take the form of reference to old situations, or which establish their own past by quasi-obligatory repetition.' Eric Hobsbawm and Terence Ranger (eds), *The Invention of Tradition*, (Cambridge University Press, 1983). Writing some years later, anthropologists Andrea Klimt and João Leal are interesting about 'the codification cultivated under Salazar of a "Portuguese" culture as a rural unchanging folk culture was aimed at enforcing conservative values and maintaining the status quo', 'Introduction: The Politics of Folk Culture in the Lusophone World', *Ethnográfia*, Vol IX (2005). http://ceas.iscte.pt/etnografica/docs/vol_09/N1/Vol_ix_N1_003 010.pdf **9** John Lewis, 'Tainted Love', *The Guardian*, 27 April 2007. **10** United Nations: *Human Development Report 2000: Trends in human development and per capita income*. **11** Gail Holst, *Road to Rembetika: Music from a Greek Sub-culture, Songs of Love, Sorrow and Hashish* (Denise Harvey & Co, 2006, pp 127-9). **12** Ed Emery, introduction to Illias Petropoulos' *Songs of the Greek Underground: the Rebetika Tradition* (Saqi, 2000). Emery also speculates on etymological links back to Persian, Arabic and Hebrew roots as well as forward to the modern Greek verb, remvo ('I wander'). Alternatively, *The Rough Guide to Greece* suggests that rembetika is derived from an old Turkish word, *harabtai*, 'meaning variously, "a shanty town", a privileged drunkard and "unconventionally dressed bohemian."' (*The Rough Guide to Greece*, 2000). **13** Holst, op cit. **14** The

Music on the margins

timeline attached to the story of how Markos Vamvakaris came to so rapid a mastery of his instrument recalls similar examples of other musicians, often from the 'wrong side', who have acquired skills at extraordinary speed. In Crete, the mastery of the lyre was said to be transmitted – by either fairies or devils – to seeking musicians, if they sat inside a circle they had drawn, using a black-hilted knife, in the earth of the crossroads. The occult symbolism of crossroads, as a dangerous place where humans trade with the supernatural, is common to many other cultures, including many west African sacred beliefs. The most famous example is that of blues guitarist Robert Johnson (see Chapter 4). In 2003, Associated News reported that one Doktor Snake, a 'voodoo practitioner from Norwich is auctioning his services on eBay to help musicians gain fame by making a pact with the Devil at the crossroads. [...] Doktor Snake claims that, during the 1990s, a number of now high-profile rock singers and musicians consulted him about performing the crossroads rite before they became famous. He says confidentiality prevents him from revealing their names. He said: 'This is a foolproof method of achieving a meteoric rise to fame and fortune.' **15** James Sclavunos, correspondence with the author, July 2008. 'So good they made it illegal', a survey of rembetika that Sclavunos, a second-generation Greek-American enthusiast, wrote for *The Guardian* (19 April 2004) provides an excellent starting point to jump into Greece's classic rembetika. **16** Holst, op cit, pp 17-18. **17** Markos Vamvakaris, from 'Alaniaris' (1935), quoted by Ilias Petropoulos, *Songs of the Greek Underground: The Rebetika Tradition* (Saqi, 2000). **18** Quoted by Holst, op cit. **19** *The Rough Guide to Greece*, op cit, p 892.

3 Discord and disharmony

'Simon Bikindi's musical compositions and live performances and recruitment, training and command of Interahamwe, were elements of the plan to mobilize civilian militias to destroy, in whole or in part, the Tutsi.'

From the indictment against Simon Bikindi at the International Criminal Tribunal for Rwanda, sitting at Arusha, Tanzania, case no ICTR-2001-72-I, 2001.

Rwanda and the Middle East: music in the service of conflict and the creation of communities... Music in the service of national identity.

JEAN BAPTISTE KAYIGAMBA remembers Simon Bikindi's music.[1] There was no reason not to: in the years before Rwanda's 1994 genocide, it was impossible not to know Bikindi. Born in 1954 in the last decade of Belgium's colonial rule over Rwanda, he was a musician, an accomplished player on the *inanga*, a type of zither indigenous to Rwanda, as well as the *iningiri*, a one-stringed bowed instrument with a resonating box. Bikindi was also a dancer, skilled in the traditions of his country's *ntore*, a war dance taught by village elders. He was the director of a folk dance company, the Irindiro Ballet, and also a civil servant in the Ministry of Youth and Sports, where he staged dance displays for visiting dignitaries, including Pope Jean Paul II in 1990.

Even before 1994, Rwanda was a society in which patronage and ethnicity counted, a place where being on-message – as far as the Government was concerned – was important for any ambitious person's career prospects. Bikindi was a well-connected man, a Hutu at the hub of Rwanda's cultural life, but it was in music that he really excelled. He became a popular songwriter. His songs were broadcast in bars, buses and other public places; as a performer he was much

in demand for wedding parties and other special occasions.

One UN official who followed his career described Bikindi as 'Rwanda's Michael Jackson', noted Donald G McNeil in *The New York Times Magazine*.[2] '[Bikindi's] style was to infuse old folk songs with new rhythms and ideas. He wrote powerful rap lyrics that mixed English, French and Kinyarwandan and set them to traditional tunes. He supplemented his government income by working at weddings, where he would sing and lead folk dances like the caller at a hoe-down. His first cassette, released in 1990, was of traditional wedding songs.'

Since 1994, there have been many other reasons to remember Bikindi, and none of them are good. In June 2001 he was arrested in the Netherlands at an asylum-seekers' center and then handed over to the United Nations' International Criminal Tribunal for Rwanda in Tanzania. He was arraigned in court on a six-count indictment that included conspiracy to commit genocide; complicity in genocide; direct and public incitement to commit genocide and crimes against humanity, including murder. In December 2008, he was found guilty of 'direct and public incitement to commit genocide' and sentenced to 15 years' imprisonment.[3]

1994

On 6 April 1994, the plane carrying Rwanda's president Juvénal Habyarimana, who was a Hutu, was shot down over the capital, Kigali. No group has ever claimed responsibility, although allegations and counter-allegations regarding culpability still make the news. However the incident triggered the hundred murderous days that followed when angry Hutus took revenge on the [minority] Tutsis and moderate Hutus whom collectively they blamed for the assassination.

On that day, Bikindi's music was everywhere – and

specifically on an independent radio station called Radio-Télévision Libre des Mille Collines (RTLM). *Mille Collines* – 'a thousand hills' – has long been a poetic trope describing Rwanda's verdant landscapes and the phrase's appearance in the name of RTLM assumes, with the benefit of somber hindsight, the dimension of rhetorical understatement.

RTLM, which was founded in 1993 and broadcast until July 1994, had always been known for its pugnaciously anti-Tutsi stance, but in its early days, it had the nickname of 'Radio Sympa' – 'Nice Radio' – for the range of Zairean/Congolese pop that was featured on its airways. A new epithet, Radio Machete, was soon coined, however.[4] For Bikindi, the 33rd signatory out of 50 creators of RTLM (the document is reproduced in an appendix in *Rwanda: Les Médias du Génocide*, the authoritative report on the genocide by the French historian Jean-Pierre Chrétien and Reporters without Frontiers), being on-message had a precise goal: the dissemination of a pernicious race-based ideology that was collected under the umbrella term of 'Hutu power'.

Music has played a part in warfare ever since Joshua's trumpets helped tear down the walls of Jericho, and even before, but never before has it been cited in a genocide trial.[5] Although the tribunal found that Bikindi had no control over the dissemination of his songs in 1994, or even that legally speaking some of his most famous songs did not 'constitute direct

The radio and the machete

'Two tools, one very modern, the other less so, were particularly used during the genocide against the Tutsis in Rwanda: the radio and the machete. The former to give and receive orders, the second to carry them out.' ∎

Jean-Pierre Chrétien and Reporters Without Frontiers, *Rwanda: Les Médias du Génocide* (Karthala, 1995).

and public incitement to commit genocide per se', they nevertheless needed to be interpreted in the political, social and cultural context of Rwanda, where they 'fan[ned] the flames of ethnic hatred, resentment and fear of the Tutsi'.[6]

Rwanda has an unhappy history of unrest between Hutus and Tutsis, turmoil that has on numerous occasions in the last century culminated in massacres. It is true to say that much of the tension grew originally from preferment for one group over another. Rwanda's former colonial masters, Germany and then Belgium, identified the Nilotic cattle-owning Tutsis as 'nobler' and 'more capable' than the Bantu-speaking cultivator Hutus, and the colonial social structures subsequently reinforced this. Following Rwandan independence from Belgium in 1962, it was difficult for the country to escape ethnic conflict and its leaders could readily use ethnicity in political mobilization.

As with all discussions of power relations in which the ascendancy of one group is relative to the debasement of another, so with Rwanda, where Hutu power was achieved at the expense of disempowerment of the Tutsis, the country's second most populous group.

Popular songs by Bikindi included 'Nanga Abahutu' ('I Hate These Hutus', alias 'Akabyutso' – 'The Awakening', see box **Nanga Abahutu**) and also 'Bene Sebahinzi' ('The Sons of Sebahinzi', also known as 'Intabaza' – 'Alert' – and 'Mbwira Abumva' – 'I Address Those who Have Ears'). These are both long compositions that called on the writer's talent for combining strong rhythms, often influenced by the Zairean (now Democratic Republic of Congo/DRC) pop music and soaring Kinyarwandan lyrics alongside a mightily skewed account of the history of Hutu-Tutsi relations.

'Nanga Abahutu', took on a distinctly nasty tone: it was a song in which Bikindi vented his ire at Hutus who denied their deep identity, their 'Hutu-ness'.

In a climate of such tension, the song was a sinister warning to Hutus who refused violence against their Tutsi neighbors. Another song, 'Wasezereye' ('We Have Said Goodbye to the Feudal Regime'), dating from 1987, was also popular. 'Those songs were playing on the radio to arouse the masses, the Hutu extremists,' Kayigamba told me. 'This is the whole point of these songs.' In an email a little later, he added, 'The texts of these songs are written in very beautiful Kinyarwanda poetry!'

Kayigamba, a former Reuters correspondent for Rwanda and the eastern regions of the DRC, is a Tutsi who was born in 1963, the year after Rwanda became independent. He was raised in Ginkongoro province, an area known for its history of Hutu extremism. 'As a child, I grew up hearing from my parents harrowing stories of the sadism and cruelty that characterized the massacres of that time,' he wrote in the *New Internationalist*. 'My father once told me that the rocks on the banks of the Rukarara River remained crimson for years because the blood of thousands of Tutsi had flowed so freely there.'[7]

On 6 April 1994, Kayigamba was living in Kigali, at the Jeunesse Ouvrière Catholique. The next morning,

'Nanga Abahutu' ('I Hate These Hutus')

'Me, I hate these Hutus,
I hate these Hutus who've renounced their identity, dear fellows,
Me, I hate these Hutus, these Hutus who march like the blind, like idiots,
I just hate the Hutus,
This kind of naïve Hutus who are manipulated and tear each other apart in a war they didn't know the cause, my dear fellows,
I hate the Hutu one can buy to kill,
Who kills, I swear, who kills the Hutu, my dear fellow.
If I hate them, so much the better.
Our luck is that they are few living among us.' ■

Simon Bikindi

Discord and disharmony

the JOC was raided by armed presidential guards; he and a handful of friends escaped to a language center run by the Catholic order of White Fathers. When the Fathers were evacuated by French and Belgian troops (flown in specially to rescue their own nationals), Kayigamba and his fellow sanctuary-seekers were handed the keys. Finally, he was able to get into the Hôtel des Milles Collines – the Kigali establishment featured in film director Terry George's historical drama *Hotel Rwanda* (2004) – where his sister was. Protected by a nominal force of UN peacekeepers, the hotel gave sanctuary to over 1,000 Tutsis and moderate Hutus. Kayigamba credits the Milles Collines' manager Paul Rusesabagina and Lieutenant-General Roméo Dallaire of the UN's Assistance Mission for Rwanda (UNAMIR) with saving his life.

From Kayigamba's large family, only he, two sisters and a niece survived. His parents, five brothers and two sisters were murdered, alongside most of his relatives, in a bloodbath that claimed between 800,000 and 1 million lives.[8] The daily rate of killing in Rwanda during those hundred days surpassed even that of the Nazis during the Second World War.

Bikindi's poetry

Yet, Simon Bikindi wrote beautiful poetry, and the beautiful poetry of his music had a hugely allegorical sweep. 'Bene Sebahinzi' is a long, winding song that addresses the original, mythological cultivator Sebahinzi himself, a character regarded as synonymous with the farmer-Hutus. During its course, other characters from history and myth are invoked; at one point a séance is held. It is a song wrapped tightly around multiple identifiers of Hutuness: what they are, where they came from, what they should do. And in the poisoned context of Rwanda, it was deadly.

The inanga-accompanied 'Nanga Abahutu' is a similarly lengthy song that takes a sardonic swipe

at Hutus who, declaims Bikindi, have lost their Hutuness, who have become deracinated and alien to a history that, in his version, is one of Hutu oppression at the hands of the Tutsis. Even reading the lyrics to either of these songs – and *Rwanda: Les Médias du Génocide* reproduces them in both their original Kinyarwanda and in French translation – devoid of the accompanying music, quickly communicates their rhetorical power. There are repetitions, lyrical hooks, questions and chatty asides. All this was accompanied by Bikindi's flair for music and poetry: rhythm and oratory united in an effective whole. Witnesses to the UN court testified to the catchiness of Bikindi's use of sitar, Rwandan-Congolese rhythms and traditional dances. ('[T]he Chamber is less interested in the score than the lyrics of his compositions,' the judges commented tersely.)[9] 'One could dance to this passionate appeal for ethnic mobilization,' writes Chrétien.[10]

Danse macabre

As a latter-day *danse macabre*, it was widely joined. Philip Gourevitch, author of *We Wish To Inform You that Tomorrow We Will Be Killed with Our Families*, the compelling survey of the Rwandan genocide, quotes a Canadian doctor, James Orbinski, who was one of only several international relief workers inside Kigali during the genocide days: 'The *interahamwe* were terrifying,' he said, 'bloodthirsty, drunk, they did a lot of dancing at roadblocks.'[11] Bikindi's music blared from the loudspeakers mounted on trucks driven by members of the Interahamwe ('those who fight together'). This was the most important of the Hutu militias and one which boasted numerous leaders of Habyarimana's ruling party, the National Republican Movement for Democracy and Development, amongst its own upper echelons.[12] RTLM radio played its part, too, broadcasting lists of wanted Tutsis, their hiding

places and the names of accomplices. Leaders and other influential people inimical to Hutu power were the first to be killed. The poet and composer Cyprien Rugamba was murdered on the first day of genocide. He was soon followed by other popular Rwandan musicians, including the singer Loti Bizimana, Nsigaye Ndumuzungu and Ntamunoza.[13]

'When the national radio stopped transmitting at 8am, [Radio-Télévision Libre des] Milles Collines would start up,' remembers Kayigama. 'Everyone had a transistor: on the street, on motorbikes, at roadblocks.' This *radio trottoir* – a kind of word-of-mouth radio characterized by its immediacy – played a special role in a country where news (to say nothing of independent news) was hard to come by. For many Hutus, RTLM's accounts of how Tutsis were attacking Rwanda and killing Hutus, placing them all in mortal danger, was taken as fact. Trucks equipped with sound systems broadcast the station, too. Kayigama recalls some phrases, such as Kantano Habimana, RTLM's chief broadcaster, talking about 'cockroaches' [to describe Tutsis]; his assurances to listeners that he spoke to Rwandans, and that Rwandans were Hutu. 'It was pure venom.'

Bikindi's music received a lot of airplay, especially during peak periods – early morning programs and those at lunchtime and early evening. His songs, the prosecution at the ICTR alleged, were 'a crucial part of the genocidal plan because they incited ethnic hatred of Tutsis and further incited people to attack and to kill Tutsi because they were Tutsi.'

RTLM's transmitters closed down on 31 July 1994 as the forces of the Rwandan Patriotic Front – a party formed by Rwandan refugees, mostly Tutsi, from conflicts that preceded the genocide – gained ground. There is now a new government, headed by Paul Kagame. It seems sad that it is necessary to say that Kagame is a Tutsi, rather than simply a Rwandan. The

'RTLM, your radio station transmitting from Kigali on FM 106 and FM 94. Greetings to our listeners, wherever they may be...'

Kantano Habimana, RTLM's chief broadcaster: 'This morning you are with Kantano Habimana and Jean Ntezimana who have selected music for you as well as all you need to make your day, 30 May 1994, a pleasant one.

'Bomb explosions in Kigali have made the headlines today. I believe the cowards are hiding under their beds. However, the good news is that our armed forces have, very early this morning at dawn, struck the *inkotanyi* [literally, 'those who fight courageously', but also a historic term of abuse for Tutsis] who now have a lot of problems because they are being shelled. Do not be afraid of all these explosions...

'[The] inkotanyi are being pursued everywhere in the banana fields. They are running... they have been decimated. [...] Help the Rwandan Armed Forces. Show them where the *inyenzi* [literally 'cockroaches', figuratively Tutsis] are hiding, be it in a WC or elsewhere and then give them what they deserve.

'For those requesting weapons, I have just been informed that they are now available. To the youth, continue with the training... you will be provided with weapons. [...] Yesterday, I saw [the inyenzi] in a church. I do not know what they were doing there. The inyenzi are indeed suicidal. I do not know if they pray in that church. But how do you pray when you are a band of criminals? They were in a Pentecostal church, the one on the hill opposite us, and they watch through the windows. What are they looking at? These people are mad. I do not understand them.

'That is the situation. Dear RTLM listeners, listen to this piece of music.

(Instrumental music, then Simon Bikindi's 'Bene Sebahinzi' plays.)

'... You understand we are in the process of exterminating the Inkotanyi in Kigali-ville. Come and assist us in exterminating them so that the population will be rid of this plague at all cost, for we shall exterminate them. There is nothing else to do.'

Extracted from RTLM tapes (RTLM/15 0016 30/5/94), © UN ICTR All Rights Reserved.
Ferdinand Nahimana, one of the founders of RTLM, was found guilty of genocide, direct and public incitement to commit genocide, and crimes against humanity (extermination and persecution) and sentenced to life imprisonment in 2003. Jean Bosco Barayagwiza, another RTLM co-founder, received 35 years. In 2002, RTLM broadcaster Georges Ruggiu received 12 years' imprisonment for incitement. Kantano Habimana is believed dead. ■

type of old identity cards – which stated the ethnic origin of its bearer – are no longer used. Even so, reconstruction is a slow job. Skirmishes between Hutu and Tutsi continue, especially in the border zones where millions of displaced Rwandan Hutus fled, and old historical grievances are not easily put aside. At the time of writing, the conflict still flares in the DRC. In April 2008, during a week of state mourning for the genocide victims, grenades were thrown into the Genocide Memorial Centre in the Kigali suburb of Gisozi, killing one policeman. There are also sporadic reports of new, anti-Tutsi hate radio stations springing up, operating perhaps from the DRC. Since the end of the genocide, Bikindi's music has been banned in Rwanda.

Will this help the country? It's a start. In the closing arguments of the Bikindi trial, the defense attorney argued that the singer's songs were about peace and democracy. There was much debate on the causal relationship between music and violence and its capacity, as RTLM's broadcasters had it, 'to heat up heads'.[14] Bikindi pointed out that most of the songs pre-dated the 1994 genocide and declared himself innocent of charges. Both sides prayed for the verdict they wanted. It's quite possible that the prayers of neither side were answered.

Wagner and racism

Maybe an analogy can be made with the informal ban against the music of Richard Wagner that operated in Israel until recently. As is well known, Wagner was Hitler's favored composer. His music was very much part of the theatrics of Nazi rallies. It is also well known that Wagner was an anti-Semite. Would he have become a Nazi had he been born in 1913 instead of 1813? Wagner's anti-Semitism went some way beyond the level of cultural and systemic anti-Semitism that was common for his era – not only in Germany, but across Europe, and the United States,

too. Ideational racism is wrong for it dehumanizes both thinker and the object of his or her distaste. But active engagement with racism, via social exclusion, or, most extremely, systematic extermination, is far worse. There are better ways of using a life than fulminating against Jews or Arabs or Hutus or Tutsis or whoever but if that really is your bent, then better that than picking up the nearest weapon and deploying it.

The Israeli embargo on the playing of Wagner's music was broken in 2001 by one of the finest of contemporary musicians. Daniel Barenboim – born an Argentinean, naturalized as an Israeli, and a Jew – led the Berlin Staatskapelle Orchestra, performing in Jerusalem, through that evening's program. A first overture was suggested, and then a second one. It was then that Barenboim asked the audience if they would care to hear some Wagner. 'There are people sitting in the audience for whom Wagner does not spark Nazi associations,' he said. 'I respect those for whom these associations are oppressive. It will be democratic to play a Wagner encore for those who wish to hear it. I am turning to you now and asking whether I can play Wagner.' A heated debate followed at the end of which Barenboim conducted his orchestra in the overture to Wagner's *Tristan und Isolde*.[15]

Not fellow-travelers

But one can really only compare like with like, and Bikindi and Wagner are not, whatever their prejudices, fellow travelers. Wagner was an anti-Semite, but he didn't stand at roadblocks urging violence; his racism was not so advanced that he wanted to exterminate Jews. Or at least, we think he would not have. Wagner, being dead, had no say in how the Nazis appropriated his music.

The judges at Arusha ruled that Bikindi's songs – specifically 'Twasezereye', 'Nanga Abahutu' and 'Bene

Discord and disharmony

Sebahinzi', songs which presented a dangerously tilted history of Rwandan relations – were 'deployed in 1994 in Rwanda in a propaganda campaign to promote contempt for and hatred of the Tutsi population, and to incite people to attack and kill Tutsi'. The broadcasting by RTLM had an 'amplifying effect' on the progress of the genocide.[16] Bikindi did not control the playlists of RTLM, but he was capable of controlling his own actions, which included traveling around Gisenyi préfecture as 'part of a convoy of Interahamwe, in a vehicle outfitted with a public address system broadcasting songs', including his own.[17]

The power of music

Our responses to music are normally thought of as individual ones, private ones. Yet the capacity of music to create a group out of a mass of single people is in no doubt. A heaving crowd at a stadium concert, the choir singing in a church, marching soldiers, a bunch of sports fans celebrating their team with their chants and songs, are in this respect no different. Music motivates. This is not to underline a causal link between music and violence. Violence, and especially organized violence, arises out of far more complex social and political circumstances, which, in the case of Rwanda, were already present in the decades that led up to the 1994 genocide.

But one of the great powers of music is that it creates and binds communities of interest. It can sing, in a common language, of shared experiences, aspirations and dreams; it can memorialize the past and honor the dead. It can channel the voice of a collective will, collective defiance or collective indignation. And woe to anyone who rubs up against the pressure of this. After 9/11, Toby Keith's song, 'Courtesy of the Red, White and Blue (The Angry American)', was indicative of a bellicose national mood (sample lyrics: *And you'll be sorry that you messed with/ The US of A/*

'*Cause we'll put a boot in your ass/ It's the American way*) that the Dixie Chicks had no truck with. Music can define who the community is and who it is not. And all these are of music, but not about it. Music can be as much about conflict as reconciliation.

Brazil's *tropicalismo*

Sometimes music can be nothing less than a manifesto. Brazil's *tropicalismo* was a multi-art movement of the late 1960s that grew out of a discontentment that was political as much as cultural. Beginning in the studios of visual artists Lygia Clark and Hélio Oitcica, its musical manifestation was contained in the work of Os Mutantes, Caetano Veloso and Gilberto Gil – who many years later became Brazil's minister of culture. Tropicalismo was subversive – it was, to use its own phrase, cannibalistic, in the manner it brought into music things from other arenas: political messages, odd time signatures from other arenas and references that Brazil's then military rulers objected to. Gil and Caetano were jailed and exiled, only later to return home.

National anthems

This brings us to the whole idea of national anthems: songs that by their very definition represent the apotheosis of community music. Maybe as a consequence of this and the various behavioral practices that surround the solemn renditions of national anthems (the hand over the heart, the audience standing, the hats doffed) the level of critical investigation into what anthems actually mean has been muted.

That the national anthem is a potent symbol – to be supported or to be usurped – is undoubted. Think of Serge Gainsbourg's 'Aux Armes et cetera', his reggae rendition of France's 'La Marseillaise' recorded in 1978 (Rita Marley, wife of reggae star Bob, contributed a risqué backing track); of the drawls of guitar

feedback with which Jimi Hendrix colored 'The Star-Spangled Banner' at Woodstock in 1969; even the Sex Pistols' 'God Save the Queen', a song serendipitously released in 1977, the year of Queen Elizabeth II's silver jubilee, that had nothing in common with the British national anthem other than its title. All three songs caused furor. Gainsbourg received death threats from French military veterans of the Algerian War and, on one occasion, hundreds of French paratroopers rioted at one of his concerts.[18]

Laibach's contributions

But by far the best inquiry to date has been made by Laibach, a band of Slovenian mischief-makers and utterly serious interrogators of power (pop and state). On their 2006 album, *Volk* (Mute), Laibach, working with Boris Benko and Primoz Hladnik of the Slovenian electronic music duo Silence, investigated what constitutes a national anthem, a format that they declare the 'perfect pop song'. *Volk*, an album interpreting 14 national anthems, is as audacious and confrontational as anything that the Slovene art band has produced in a 26-year career that's never been far from controversy.

That is possibly because Laibach – their name is the German word for Ljubljana – have always been interested in how emotion and music work together. Packaging themselves in a Wagnerian, minimalist disco and a visual aesthetic that, by mimicking totalitarian art, subverts it, Laibach's strategy has always been to parody the spectacular – from the party congress to the stadium rock crowd – to the hilt.[19]

If it is a tactic that leaves them open to misinterpretation, it is superb when it works and on Volk it most certainly does. National anthems are prized apart: hymnal qualities as well as triumphalist tones arise. 'God save your gracious queen,' intones the voice on 'Anglia', as a string quartet gives way to brooding

electronics. 'America' is more hysterical: 'We are all people of God,' rants a preacher who is spliced into 'The Land of the Free'. Spain gets off easily, with a few mordant cries of 'Viva España' and 'Olé!' It's no coincidence that the closing anthem is for NSK (Neue Slowenische Kunst or New Slovenian Art), the virtual state of which Laibach and their larger circle, the artists and theorists of the IRWIN group, are members. Hunting horns blare, snazzy drums join in but it's nothing as martial as one would expect. A computerized voice quotes snippets of Winston Churchill: 'We shall defend our state... We shall never surrender.' And then the sound of a needle running off a vinyl record.

Israel and Palestine

But out of all the tracks on *Volk*, the most provocative one has to be 'Yis'rael'. Based on a blend of two existing national anthems, Israel's 'Hatikvah' (The Hope) and Palestine's 'Biladi' (My Country), the voices wind back and forth: English, Hebrew, Arabic. *'Our hope will not be lost, the hope of 2,000 years,'* growls Laibach's vocalist Milan Fras, as guest vocalist Artie Fishel murmurs other lines from 'Hatikvah' in Hebrew. Then the scratchy electronic ambience gives way to a thunderous beat. It's the beginning of 'Biladi' rising up to the surface: *'My country, my country, my ancestors,'* intones Fras. One of the last words in Laibach's 'Yis'rael' is 'homeland'; this is a song of two voices yearning for the same country.

Laibach's song is a simple statement of truth: no voice triumphs in 'Yis'rael'. What the song doesn't do – or cannot do within the remit of their national anthems program – is express the morass of horror that underpins those two voices and their current relations: the Nazi Holocaust against the Jews, a horror that provided the world with a persuasive force in the foundation of the state of Israel in 1948; the brutality

with which Palestinians were cleared from their homes
by Israelis and the systemic violence still practiced
against them; the acts of aggression, both minute and
catastrophic and always grotesque, that continue; the
grief of all those who mourn. 'Who counts as human?
Whose lives count as lives?... What makes for a griev-
able life?' asks the philosopher Judith Butler in the
context of her powerful essay on the post-9/11 world.
In conflicts where enemies are routinely demonized
as anything less than human, it is the most pertinent
question to ask.[20]

Who are you singing for?

Music does not exist in a vacuum. It is created out of
communities, knowledge and resource. It is – except
in the rarest cases – designed to be listened to. But
even this is not so simple. What are you singing?
And in doing so, what are you representing? In 2006,
Reem Kelani, the London-based Palestinian singer
and composer, recorded (and financed) a wonderfully
accomplished debut album called *Sprinting Gazelle*
(Fuse). It wasn't her first recording: Kelani, who
trained as a marine biologist before taking up music as
a profession, had long been a guest presence on other
people's jazz albums.

She was no ingénue and much thought went into
the album's presentation and content. The cover of
Sprinting Gazelle features a gazelle ('reem' in Arabic);
there is rue, the herb with which the olives of Nazareth
– the hometown of Kelani's mother – are always
pressed; the background shows a creamy white fabric
covered in cross stitch, a pattern local to Galilee.

Sprinting Gazelle's ten songs include traditional
Palestinian songs (many gathered in refugee camps)
that pre-date 1948 and contemporary songs and
lyrics from writers (including such prominent ones as
Mahmoud Darwish and Salma Khadra Jayyusi) who
were born before 1948 in the land that is now Israel.

The album's catalog number is, significantly, the number 48. And yet, Kelani acknowledges, she was criticized by some within Palestine for not draping the album in the colors of the Palestinian flag or indulging in the kind of belligerent imagery – what she terms 'emotional pornography' – that adorns the sleeves of so much 'political' music from Israel and Palestine. It's a fraught situation: to be an artist is to be seized upon by those who want to claim (or conversely, deny) you for their own aims.

Community makes the music

Sprinting Gazelle is an album in which the personal merges with the political, not because Kelani aligns herself with any faction (she is careful not to), but because of the third 'P' word: Palestine. The album's subtitle *Palestinian Songs from the Motherland and the Diaspora* is a political statement in as much as anything to do with the history and contemporary existence and constitution of Palestine is political.

'Music defines a community, but conversely, the community makes the music,' Kelani points out. 'Israelis deny there is something called Palestinian music. When you deny my existence it is a lot worse than victimizing me. When you victimize me, you acknowledge that I'm there, although I might be a subspecies like Hitler did with the Jews. He considered them as a subspecies, subhuman. But if you deny my music, you deny my existence. The good side of this is that you realize that you're not a victim – because you don't exist. And not feeling a victim is something quite empowering. When I say I am not a victim, I'm fearless.

'The whole point is to say that there is something called the Palestinian musical cultural narrative. When I say that I recorded *Sprinting Gazelle* for selfish reasons, I do not mean for fame and profit,' Kelani continues. 'I needed to do it to say that I existed.'[21]

Discord and disharmony

To resist those who want to pull *Sprinting Gazelle* one way or another is a brave thing to do. And it is an album with resonances that stretch back into history. Its opening song, for example, 'As Nazarene Women Crossed the Meadow', was sung by women as their menfolk were conscripted into the Ottoman army during the 19th century. And yet even so, the album navigates a minefield. For all its celebrations of memory and resilience, it's also a lament for what once was – a cultural Palestinianism, in which Christian, Jewish and Muslim threads came together – and will be no more.

Rim Banna, the Nazareth-based Palestinian singer who has recorded traditional lullabies and songs – many of which were on the point of extinction – covers some similar territory to Kelani. Both artists are fiercely aware that so often it is this kind of music, intimate and quiet, that transmits a historical sense of continuity and belonging. Lullabies as a deliciously subversive tactic was the remit of the cleverly named 2004 album *Lullabies from the Axis of Evil*, which Banna contributed to.

West-Eastern Divan Orchestra

The idea of a shared culture or perhaps a shared cultural aspiration is what characterizes Daniel Barenboim's own initiative in bringing Israelis and Palestinians together. Founded in 1999 by Barenboim and the late Edward Said, the renowned Palestinian-American historian, the West-Eastern Divan Orchestra was conceived as a humanitarian idea. It is an orchestra of accomplished young musicians from diverse backgrounds: Israelis and Palestinians, and more recently also players from Egypt, Syria, Lebanon and Jordan. They meet regularly in summer schools held in Seville – the ancient Spanish city in which both Moors and Jews once co-existed in peace and prosperity – and then go out on tour. The Divan

Daniel Barenboim

'The West-Eastern Divan Orchestra is not a love story, and it is not a peace story. It has very flatteringly been described as a project for peace. It isn't. It's not going to bring peace, whether you play well or not so well. The Divan was conceived as a project against ignorance. A project against the fact that it is absolutely essential for people to get to know the other, to understand what the other thinks and feels, without necessarily agreeing with it. I'm not trying to convert the Arab members of the Divan to the Israeli point of view, and I am not trying to convince the Israelis to the Arab point of view... I'm trying to create a platform where the two sides can disagree and not resort to knives.' ∎

Daniel Barenboim speaking to Ed Vulliamy. © Ed Vulliamy, *The Observer*, 13 July 2008.

(the name comes from the title of an epic poem by Goethe and refers to the Ottoman word for a council room) is, to use a musical metaphor, an appeal for the acceptance of counterpoint – that is, the existence of individual voices.[22] And while counterpoint is not exactly the same as harmony, contrapuntal lines can nevertheless create a semblance of harmony if their voices can create a dialogue that eschews discord. Musicians have to listen to each other, Barenboim stresses, they need to act in concert.

Barenboim is too astute to say that this endeavor will result in peace; but it will, he says in a short speech at the end of the Divan's *Live in Ramallah* (Warner Classics, 2006), bring about the 'understanding, patience and the curiosity to listen to the narrative of the other'. Even so, the recording of this album in the West Bank town of Ramallah required statesman-like powers.

The only way that the musicians could enter the closed-off town was on diplomatic passports issued by the Spanish Government. In Israel, Barenboim was denounced as a self-hating Jew. But the orchestra played, and its program is iconic: Mozart's Sinfonia concertante; Beethoven's Fifth, with its play between light and dark timbres; and finally, the

richness of Elgar's Enigma Variations.[23]

But if Barenboim found it difficult to get past
the cordons of the Israeli Defense Force and into
Ramallah, imagine how it must be for those who lack
his political clout. Life in Ramallah might have its
grim aspects, but some reportage gets out. In much
the same way as the politicized lyrics of mid-1980s
American rap – Public Enemy, Scott La Rock and
KRS-One, for instance – have often been compared
to news flashes coming fresh from the streets of New
York's boroughs, so it is with Palestine and Israel.

Hip-hop's role

Given the ascendancy of hip-hop not only as global
music, but a genre recognized as an authentic voice of
protest, it's not surprising that it is rap that's provid-
ing Palestine and Israel with its present soundtrack.
And not just in Palestine and Israel. Rap has proven
to be exportable in a way that mid-1970s punk never
managed to be. It is now the lingua franca of the
youth in the French banlieues and, in its harder form
of grime, the British inner cities. There is also Iraqi
rap; Iranian rap; Brazilian rap in the form of Rio de
Janeiro's radical *favelistas* AfroReggae and, across
Africa, a huge swathe of MCs. In just one country,
Guinea, rappers – rather than following the tradi-
tional role of praise singers – are seeking to shame the
corrupt leaders of their dirt-poor land.

Checkpoint 303

The medium may be derivative, but the messages are
not. Checkpoint 303, an international collective whose
members and fellow-travelers are spread between
East Jerusalem, France and Yemen, are chief among
the most innovative responses to the Israeli impasse.
Formed in 2004 as a Tunisian-Palestinian duo by two
'sound catchers', SC MoCha and SC Yosh, Checkpoint
303 are as much influenced by experimental music

and its sense of place as they are by politics.

'First, we are artists not politicians, and second, we've always said that the message we spread through our music is beyond political orientation and beyond religious beliefs, it is deeply "human", says MoCha. 'In other words, it calls for the respect of fundamental human rights. Equality, freedom and justice need not have a political nor a religious face.' Using small recorders, Checkpoint 303 make field recordings that portray everyday life in Palestine. They are named after a real checkpoint that separates the West Bank town of Bethlehem from Jerusalem, although, as they acknowledge, it is a name that has tones of 'an aesthetic of numerical symmetry strongly present in electronic music' in its hints towards 303 drum machines and bands and artists such as Front 242, 808 State and Kid 606.

'The idea is not to go after a particular sound that would convey a particular message,' says MoCha. 'On the contrary, we try – to the extent to which this is possible – to record random sounds of daily life in the Middle East. The point is, we want to provide a natural portrayal of what life sounds like in Palestine. The media provides a view that is biased by political powers and by 'sensationalism'... trivial stories never make it to the news. But in fact it is the trivial things that embody a search for normal life.'

Freely available from Checkpoint 303's website (subtitled 'Free Tunes from the Occupied Territories'), the tracks they construct are elegant, elegiac affairs. A snip of language, such as 'There's a lost ID' (which is the recurrent motif on 'Hawiya Dhay'a' – 'Lost Identity') or the 'Hello? Hello?' (and the answering machines that respond on 'Gaza Calling') are brilliantly conceived tropes for a society under siege. 'Streets of Ramallah' features gunfire in celebration of a Fatah victory party. Listen to a 303 track and you might hear horoscopes, traffic jams, the voices of

old Arabic poets made distant by time and scratchy records, radio static. Field recordings are joined by loops, samples and the other devices that create and structure electronic music. It's a poetic dance music that has a closer affinity to the collages of Brian Eno and David Byrne's *My Life in the Bush of Ghosts* than it does the righteous ire of Public Enemy.

There is no vainglorious bluster about Checkpoint 303. It is, says MoCha, naïve to think that their music could change the world. 'However, we hope that it will help promote international awareness and contribute to a more global movement that seeks to counterbalance the biased depiction of the situation in Palestine and in the Middle East,' he says. Checkpoint describe their music as 'an act of resistance and a celebration of hope', but it is far more than that. In their concentration on the frangible, they contact something that is truly fragile in human life – and that is all the more valuable for it.

Who's the terrorist?

Ambient sound is also an important component of Ramallah Underground's music. Boikutt, Stormtrap and Aswatt, the MCs who make up the RU trio, take snatches of local noise – in their case, military hardware rattling along in their neighborhood – and scraps of melody lines from Arabic songs, including those of icons such as Om Kalsoum and Fairuz, to flavor a hard-edged rap in Arabic, French and English. Only Boikott lives in Ramallah these days – his colleagues are in Dubai and Vienna respectively – but the band's intent to mobilize a musical resistance is still strong. The geographical spread has also widened the band's range of influences – a moody electro-wash has been added to the earlier cut and splice rap.

Their bricolage approach has, most recently, attracted the interest of the San Francisco-based Kronos Quartet, the world-acclaimed classical musi-

cians who have made it their life's work to seek out new repertoire, and also the Faithless guitarist Slovo, who plays on the band's song 'Nakba'.

Brothers Tamer and Suhell Nafer and Mahmoud Jreri, the trio who make up DAM – Da Arabic MCs (the name translates as 'blood' in Hebrew and 'eternity' in Arabic) come from a rundown, mixed-race section of the Israeli city of Lod. They work in a fluid mixture of Arabic, English and – to get their message over – Hebrew. 'Born Here' – *It's just that the city didn't care for the Arabs/ Because the government has a wish/ Maximum Jews – on maximum land/ Minimum Arabs – on minimum land'* – is one example of DAM's foray into (mostly) Hebrew. Although DAM have a number of CD releases to their name, most significantly *Min Irhabi? (Who's the Terrorist?)* from 2001 and *Dedication* (2006), the band, like Ramallah Underground, rely on the internet to get much of their work distributed. And it was this medium that really brought DAM to wider attention.

The song that stood out from DAM's 2001 album was its title track; within a month of the album being released, over one million people had downloaded 'Min Irhabi?'. The softish backing track to the Arabic rap, replete with a woman's voice contributing some gentle melismatic lines, is belayed by its accompanying video. Easily viewable on YouTube, the video for 'Min Irhabi?' is jammed with footage of stone-throwing Palestinian boys; Israeli soldiers firing off salvos; old men weeping in the ruins of their olive groves. As with all images of violence, all images of oppression, these are terrible to behold.

But 'Min Irhabi?' was that most alchemical of things: the right song for the right time, a song that connected with the mood of not only Palestinians but, more amorphously, with those whose ears were attuned to the genuine voice of righteous indigna-

tion. It was a song that crossed linguistic and cultural borders: soon, the song had found its way onto university courses and cover-mounted CDs that come free with magazines. It remains a hard-hitting song, and, in its ire, the comparisons are not always well placed or appetizing:

> 'Who's a terrorist? I'm a terrorist?
> How am I a terrorist when you've taken my land?
> Who's a terrorist? You're the terrorist!
> You've taken everything I own while I'm living in my homeland,
> You're killing us like you've killed our ancestors.
> You want me to go to the law? What for?
> You're the witness, the lawyer and the judge!
> If you are my judge,
> I'll be sentenced to death.
> You want us to be the minority?
> To end up the majority in the cemetery?
> In your dreams!
>
> You're a democracy?
> Actually it's more like the Nazis!
> Your countless raping of the Arabs' soul
> Finally impregnated it
> Gave birth to your child
> His name: Suicide Bomber
> And then you call him a terrorist?'

from 'Who's the Terrorist?', © DAM

Tel Aviv's rapper

On the other side of the fence – or in this case, the Separation Wall – it is a beefy twentysomething of Sephardic extraction who's been making most noise for Israel's rightwingers. Kobi Shimoni, better known

as Subliminal, is not known for his sophisticated *Realpolitik*. 'We have this little sandbox we call Israel. We give our hearts and lives to make it a proud country,' the Tel Aviv rapper told a writer for the US rock magazine, *Rolling Stone*. 'Everyone serves in the Israeli Defense Force in order for Israel to survive. You have half of the globe. What the fuck do you want from us? Go live in Saudi Arabia.'[25]

For a small country, Subliminal is a big seller. It has been estimated that one household in five owns a Subliminal album. His hyper nationalism could be read in the light of the tensions that exist in Israeli society between European-originating Ashkenazi Jews and their Middle Eastern Sephardic counterparts. Songs such as 'We Came To Expel Darkness' and, in a piece of appropriation as stunning (and arguably more dangerous) as that of Laibach, 'Biladi' – which appalled as many listeners as they enthralled – express a heightened sense of identification with an Israel that has, despite its location in the Middle East, historically been dominated by Ashkenazi Jews.

Is it that the Sephardic rapper needs to make himself out to be more Jewish than the Jews? He adorns himself with rhinestone necklaces on which the Star of David features prominently. The sleeve photo for *The Light and the Shadow*, the album made with his rap partner and former army comrade Shadow (aka Yoav Eliasi), features a besmirched, battle-hardened fist clutching a glittering Star of David. At gigs, Subliminal asks his fans to jingle their army dogtags for all to see. The first 20,000 pressings of *The Light and the Shadow* came with free Star of David necklaces. For Shimoni, youth rebellion has meant rejecting the prevailing liberalism that surrounded him as he grew up. 'The role models [my generation] had as children were rock artists saying, "Fuck your head up, fuck this country, fuck this army, fuck religion, fuck the culture, we don't come from that, we're the new generation",' he

Discord and disharmony

told writer Dorian Lynskey of the webzine *Guilt &*
Pleasure, in 2006.[26]

Subliminal separation

Despite more cautiously conciliatory songs – 'Flowers
in the Barrel' from 2004 updates an old army song
with hopes of two nations living in peace – Subliminal
remains a divisive character in today's Israel. For the
liberal left, he's the epitome of the type of belligerent
Zionism that does the cause of peace no good. For his
fans, he articulates a brash and robust populism that
perhaps ameliorates any doubt about the relationship
between Israel and its Palestinian shadow side.

And then there are those for whom Subliminal
represents the working-class guy made good; the one
who runs TACT (it stands for Tel Aviv Street Team),
an organization that embraces a clothing label, a
recording and distribution company, its own hip-hop
crew and some clubs, the guy who fronted an anti-
drugs campaign for the government; the guy who
walks the gangsta walk, but in reality is very straight
indeed.

That said, nothing in the politics of Israel and
Palestine is simple, and the same goes for rap.
Subliminal was once a friend and collaborator with
DAM's MC Tamer Nafar and their fallout – over poli-
tics – is painfully captured in Anat Halachmi's docu-
mentary *Channels of Rage* (2003). Another docu-
mentary, *Slingshot Hip Hop* (2008) by director Jackie
Reem Salloum, traces the relationship between rap
and the intifada. One of the 20-plus rappers appear-
ing in it points to his CD of Public Enemy's *Fear of a
Black Planet* and says, 'In this country, there's fear of
an Arabic Nation.'

There is something in this comment that is reminis-
cent of what the Ugandan political scientist Mahmood
Mamdani wrote in 2002 about the aftermath of the
Rwandan genocide:

'The Tutsi want justice above all else, and the Hutu want democracy above all else. The minority fears democracy. The majority fears justice. The minority fears democracy is a mask for finishing an unfinished genocide.'[27]

And in such circumstances, rap, with its ethos of 'telling how it is', cannot fail to be politicized, radicalized.[28] And yet Israel and Palestine offer many other notable examples of hip-hop that adopt different tacks. Y-Love (aka Yitzchak Jordan) is an Orthodox Jewish rapper whose album *This Is Babylon* seeks greater religious understanding, and peace, with the Palestinians. Hadag Nachash ('Snake Fish', but also a complicated Hebrew pun about new drivers – the metaphorical meaning tilts towards something like 'it's youth in the driving seat') use funk, jazz and rap to deliver witty, one-eyebrow-raised work that is firmly on the side of the liberal left (see box '**The Sticker Song**').

The band's 'Sticker Song' (2004), with lyrics scripted by the novelist David Grossman, is a list of slogans from popular Israeli car stickers that, taken together, build up a wry if remorseless picture of the culture that made them. Sagol 59 (aka Khen Rotem) – 'Purple

'The Sticker Song'

A whole generation demands peace
Let Tsahal [the Israeli Defense Forces] win
A strong nation makes peace
Let Tsahal play hardball
No peace with Arabs
Don't give them guns
Combat is the most, bro
Draft everybody, exempt everybody
There's no despair in the world
The territories are here! ∎

© *Hadag Nachash*

Discord and disharmony

59' – is a Jerusalem-based MC whose 2001 'Summit Meeting', made with DAM's Tamer Nafer and Hadag Nachash's Sha'anan Streett was the first attempt to broker some kind of mutual working space between Jews and Palestinian rappers. He continues the work by hosting the Corner Prophets (which takes as its motto Simon and Garfunkel's line, 'the words of the prophets are written on the subway walls'), a cross-cultural, multimedia platform for all hip-hop-minded people interested in dialogue. Then there's PR (the Palestinian Rapperz), and the NOMADS (Notoriously Offensive Male Arabs Discussing Shit).

Other sounds

Outside of the Middle East, the Martin Luther King sampling, Oakland-based Iron Sheik (aka Will Youmans) is worth looking up, as is the KABOBfest blog, a forum he and several other Arab-Americans set up to discuss Middle Eastern politics, culture and more besides; so too are the Los Angeles-based Philistines. Many of these artists can be heard on *Free the P* (2006, Raptivism Records), a compilation album that gives a wide range of the hip-hop on offer. And in New York, JDub Records, a not-for-profit label set up in 2002 by students Ben Hesse and Aaron Bisman, seeks out and promotes 'innovative Jewish music' (Sagol 59 is on their rosta) on a multicultural platform. In the UK, a website run by oncologist Tariq Shadid called the Musical Intifada similarly has much to recommend it.

Outside of hip-hop, Ronni 'Macaroni' Shendar and Till 'Glitterbug' Rohmann are the founders behind the Jerusalem-based c.sides festival. Focusing on electronic music, c.sides is an independent organization, seeking to create a 'structured platform of convergence' for social activism and arts. The two members of the festival's curatorial team see music and arts in a context of social justice and human rights. As one might expect, c.sides does not get an easy ride from the Israeli authori-

ties. However, the organizers have been able to plug into a secular-minded, critically engaged community of artists in Israel and the occupied territories.

Music's role in conflicts

If there are some musics whose turbulence echoes the violence of the society that spawns it, there are also some that seek to transcend aggression. Barenboim, who believes that no consensus can be built through brutalization, uses the classical repertoire in an attempt to transmute violence into – if not peace, then something on the way towards peace. DAM, with all their hard-edged beats, bang an eloquent drum for the underdog and do it loudly. Subliminal bangs his drum with equal volume towards another end.

In many ways, both these outpourings are predictable. Less so are the more reflective routes. Checkpoint 303 take a thoughtful route; their activism is also a kind of memorializing. So too is Reem Kelani's canon, which refuses the chaos that has grown out of 1948 – what the Palestinians refer to as the *nakba*, the catastrophe – by a turning towards material that, for the most part, pre-dates or is unpolluted by that disaster.

And yet, there is a paradox at play. The more one averts the eyes, they more one sees, and Kelani's graceful songs resonate with the sadness of knowledge. If Simon Bikindi really was an all singing, all-dancing, one-man 'Horst Wessel Song'[29], if he truly knew what the impact of his actions were in Rwanda, he either lacked imagination or had too much of it. Whichever, it was an unredeemable combination.

Emmanuel Jal

But many have survived conflict to create something good from it. Emmanuel Jal had, by his early teenage years, seen action in two civil wars as a child solider in Sudan. Pulled out of the maelstrom when he was smuggled into Kenya by a British aid worker who

briefly became his foster mother before being killed in a car crash, Jal took up music-making to deal with his past. In 2005, he recorded *Gua* ('Peace' in Jal's native language of Nuer), followed by *Ceasefire* (with Abdel Gadir Salim) in 2005 (Riverboat/World Music Network) and, three years later, *War Child* (Sonic 360).[30]

While Jal has embraced hip-hop (and a fluent use of English flowing into lyrics in Nuer and KiSwahili) in his music, he is also very much a man with his own ideas. *Ceasefire*, made with the Sudanese *oud* player Gadir, peppers beats with more gentle Sudanese percussion, brass and rhythmic lines, and, importantly, a lyrical content firmly on the side of peace. *War Child* is perhaps the smoother album – if smoothness is measured in terms of a sleek-sounding MOR hip-hop style – but it may yet be the mass-market breakthrough for the young artist. The next MC Solaar? Possibly.[31]

Starry nights in Beirut

There is another way: to play with the conflict in question. The Lebanese improvisational trumpeter Mazen Kerbaj was in Beirut in the summer of 2006 when the Israeli air force bombarded the city. 'Starry Nights' was one of his responses to being caught in the crossfire. Described on his website, somewhat sardonically, by the musician as a 'minimalist improvisation' featuring Mazen Kerbaj on trumpet and the Israeli air force on bombs, 'Starry Nights' was recorded on the balcony of his Beirut flat.[32] It's something that begins quietly – the piece was recorded in the middle of the night after all – and then flat trumpet notes course out. The shaking bass notes are explosives detonating, the thin melody lines that follow are car alarms and emergency sirens. Spontaneous composition of this type is not only a characteristic of improvised music that has grown out of twin, frontier-crossing worlds

of jazz and experimental music. Incidentally, Kerbaj is a significant figure at Irtijal, the excellent international festival for experimental music that has run in Beirut every year since 2000.

Balkan turbo-folk

Conflict has often recruited folk music into its ranks. During the break-up of Yugoslavia in the 1990s, at a time when much of the first/rich world was seeing an extraordinary expansion in club music, a different music rose to the fore in Serbia. Named turbo-folk, it wasn't really a new phenomenon at all, rather, as cultural theorist Alexei Monroe has it, it was a 'high-tempo collision of a traditional folk (including nationalist songs) and contemporary dance rhythms'.

A banal, Balkan, Euro-disco, turbo-folk was never intended as a malign force. Its tag had been coined some years ago by the flamboyantly (self-)named Rambo Amadeus – it sounds better than Antonije Pusic – a prankster and political cynic who wanted something to describe his own synth-driven music. Amadeus himself had long had a taste for irony which had got him into trouble with the country's old communist leadership. So it must have been a shock when turbo-folk transmogrified into something very un-ironic indeed. By the mid-1990s, its queen was Svetlana Velickovic, better known as Ceca. Her husband, who until his assassination in 2000 was best known simply as Arkan, was the leader of the Serbian nationalist Tiger militia.

With the defeat of Serbia, turbo-folk faded. Although Balkan clubs still shake to the beats that work Greek pop, Gypsy music and brass band riffs (all now filtered through digital technology), the nationalist component has slithered away. How dangerous was it really when Ceca sang about how she would die for her 'beloved'? Did she mean her lover or was there an allegorical meaning? As we have seen with Simon

Discord and disharmony

Bikindi, it is the allegories and their contexts that need to be closely watched.

Serbia is not Rwanda. Despite the atrocities committed in the territories of the former Yugoslavia, there were some valiant attempts to resist the war waged by Serbian leader Slobodan Milosevic. The pirate radio station B-92, with a playlist that ranged from the Clash and Public Enemy to drum 'n' bass, was an important example. Music can be a weapon, but the efficacy and justice depend on who wields it and to what ends.

Music can convey a multiplicity of messages, but it cannot completely control how it is heard – as we shall see next in the case of the blues.

1 Jean Baptiste Kayigamba to Louise Gray, 2008. For Kayigamba's personal account of the 1994 Rwandan genocide, see *New Internationalist*, June 2006, issue 390. **2** Donald G McNeil Jr, 'Killer Songs', *The New York Times Magazine*, 17 March 2002. **3** The ICTR's amended indictment of 15 June 2005 against Simon Bikindi is online at http://69.94.11.53/ENGLISH/cases/Bikindi/indictment/bikindi05.pdf. **4** The website of Radio Netherlands has a short example of an RTLM broadcast at http://www.radionetherlands.nl/features/media/dossiers/rwanda-h.html. The website itself has many useful links to the whole subject of hate radio. **5** Music continues to be used as a tool of warfare. Besieged Fallujah was barraged by soundtracks of heavy rock music, including Metallica; at Guantanamo Bay, inmates have been treated to Eminem, 'I Love You, Barney the Dinosaur' and Dr Dre. A recent development has been that the artists themselves are now beginning to object to the use of their work in conflict and torture. See: www.guardian.co.uk/music/2008/dec/11/gunsnroses-elvis-presley-human-rights. **6** The Prosecutor v Simon Bikindi, case no. ICTR-01-72-T, Judgment, paragraph 264, p 64. **7** Jean Baptiste Kayigamba, 'Haunted mornings, sleepless nights', *New Internationalist*, June 2006, issue 390. **8** Gerald Caplan, 'Rwanda: Walking the Road to Genocide' in Allan Thompson (ed), *The Media and the Rwanda Genocide* (Pluto Press, 2007). **9** The Prosecutor v Simon Bikindi, op cit., paragraph 196, p 47. **10** Jean-Pierre Chrétien and others, *Les Médias du Génocide* (Karthala, 1995) pp 355-358. **11** Philip Gourevitch, *We Wish To Inform You that Tomorrow We Will Be Killed with Our Families* (Picador, 1998) p 134. **12** The other sizeable, though less organized, Hutu militia was called the Impuzamugambi ('Those who have the same goal'). It was even more fanatically anti-Tutsi than the Interahamwe. Both militias were armed by the Rwandan army. **13** Eugene Mutara, 'Mussamba Raps Simon Bikindi', *The New Times*, Kigali, 8 April 2008, http://allafrica.com/stories/200804090217.html **14** The Bikindi trial has implications for free speech and censorship in music. See www.freemuse.org. The ICTR judges considered these thoroughly. **15** Fred Mazelis, 'Daniel Barenboim conducts Wagner in Israel', 1 August 2001, www.wsws.org/articles/2001/aug2001/wagn-a01.shtml **16** The verdict of the ICTR against

Simon Bikindi, 2 December 2008. For a full transcript, see http://www.unhcr. org/refworld/pdfid/493524762.pdfBiki **17** 'When heading towards Kayove [towards the end of June 1994], Bikindi used the public address system to state that the majority population, the Hutu, should rise up to exterminate the minority, the Tutsi. On his way back, Bikindi used the same system to ask if people had been killing Tutsi, who he referred to as snakes.' The Prosecutor v Simon Bikindi, op cit, paragraph 422, p 104. **18** In 2006, 'Nuestro Himno' ('Our Song'), a Spanish-language version of 'The Star-Spangled Banner', has caused controversy. **19** Laibach's tactics have also influenced the Israeli-born artist/musician Anat Ben-David, who explores the links between the media and mass consumerism on *Virtual Leisure* (Chicks on Speed Records, 2008). *Popaganda*, Ben-David's larger and ongoing project, looks at the similarities between the figures of the performer and the dictator. **20** Judith Butler, 'Violence, Mourning, Politics', in *Precarious Life: The Powers of Mourning and Violence* (Verso, 2004). **21** Conversation with Louise Gray, 2008. **22** This said, there is scholarly debate as to the extent that the poem is itself an orientalist fantasy of Goethe. **23** Nimrod, the ninth of Edward Elgar's *Enigma Variations*, is a work intimately associated with the British military, being played annually on Remembrance Sunday at the Cenotaph in London. As such, it seems like an unusual piece to perform in Jerusalem, a city in which the last bloody days of the British Palestinian Mandate were spent. **24** Email correspondence with Louise Gray, 2008. **25** Loolwa Khazzoum, 'Israeli Rapper Takes US', 2 March 2005. www.rollingstone.com/news/story/7069855/israeli_rapper_takes_us **26** Dorian Lynskey, 'Two Sworn Enemies and a Microphone'. Lynskey makes the important point that, while MTV's arrival in Israel in the early 1990s popularised rap there, it was the outbreak of the second intifada in 2000 that provided the genre with its *cause célèbre*. www.guiltandpleasure.com/index. php?site=rebootgp&page=gp article&id=10 **27** Quoted in Caplan, op cit, p 30. **28** One exception to this is Matisyahu, the Pennsylvania-born cult Hassidic rapper whose work references roots reggae and rap in equal amounts. Invoking the Biblical authority that much roots reggae employs, Matisyahu finds a strong medium in which to base his orthodox Jewish themes. **29** This was the anthem of the Nazi party in Germany from 1930 to 1945. **30** *Warchild* is also the title to both a documentary on Emmanuel Jal and African hip-hop, plus a forthcoming autobiography. **31** As a style, hip-hop is exerting much influence on African rappers and musicians. *Many Lessons: Hip-hop, Islam, West Africa* (Piranha, 2008) is a 14-track compilation album featuring such new artists as Nigeria's Bantu, Senegal's Sister Fa and, from the Republic of Guinea, Silatigui. All the musicians appropriate hip-hop into their own styles and traditions, while the lyrics take on issues as various as the abuses of religion, genital mutilation and AIDS. **32** See www.kerbaj.com for Mazen Kerbaj's art, music (an excerpt of 'Starry Night' is online) and a compelling blog describing life in a war zone.

4 Looking for the blues: authentic misery

'Selling your soul to the devil is an intimate, personal thing...'
Will Hodgkinson, *Guitar Man.*

'I was taught to be ashamed of the blues. We thought of it as plantation darkie music.'
Isaac Hayes, quoted by Gerri Hirshey, *Nowhere To Run: the Story of Soul Music.*

Dicing with the devil... Imaginings of things lost... The romance of the desert.

ONE LONELY NIGHT a few years after the millennium, Will Hodgkinson set off to sell his soul. The writer had left his London home for a crossroads located a few miles outside of Clarksdale, Mississippi. It wasn't just any old crossroads that Hodgkinson was heading for, but a crossroads that has become the location of legend. It was here, at the intersection of Highway 61 and Highway 49, one midnight in 1930 or 1931, that Robert Johnson (1911-38), the most mysterious of all the early bluesmen, himself encountered the devil – in the form of a big black man – and, in exchange for his soul, was given the gift of guitar-playing. So it was said.

Folklore is fond of crossroads. Multiple cultures (and comparative folklorists) have stories to tell of the supernatural meanings of these sites that offer diverging ways and the danger of choice. The Greeks and Romans designated their messenger god (Hermes or Mercury respectively) as the divinity of the crossroads. West African beliefs, which still survive in the diaspora, situate Papa Legba – the intermediary between the spirits and humans – at the crossroads. Indian, Latin American and European folk beliefs all have their own versions of the gods and ghouls to be

found at the place where roads meet. Sometimes the crossroads are gateways to demonic presences, and at other times, trickster figures. Sometimes the movement of peoples, and the superimposition of one belief system onto another, leads to the creation of new characters, who are no less spooky for their syncretic origins. In the case of the blues, the obvious example is the transportation and enslavement of countless Africans in the Americas.

Sold to the devil

It is said that the soul of the pioneering ragtime pianist and self-styled 'originator of jazz' Jelly Roll Morton (c1885-1941) was sold to the devil by his aunt, a voodoo priestess in New Orleans (some accounts say it was his godmother), in return for prodigious musical talent.[1] It's no coincidence that in *Searching for the Wrong-Eyed Jesus* (2003), director Andrew Douglas's superb documentary on the music of the American South, Brett and Rennie Sparks, the husband and wife duo who make up the Handsome Family, are found at a Louisiana crossroads performing their own update on a second-coming song: *'There'll be power in the blood/ When that helicopter comes.'*[2]

Hodgkinson's *Guitar Man*, a good-natured account of how his own ambition to play like his axe heroes bled into a fascination with the much-mythologized bluesman Johnson, is a central theme of the book. In the event, a black man, more toothless than demonic, does come up to Hodgkinson that night:

'Let me guess. Are you selling your soul to the devil?'

'Well, I...'

'The devil's done got tired of young men trying to skip on their guitar lessons... You must be the third this month.'

Of course, some maintain that Johnson, born 1911 in Hazlehurst, Mississippi, who was poisoned by a

jealous husband in 1938 with just 29 recorded songs to his name, never met the devil at all that night. Hodgkinson suggests that it was another Delta blues-man, Eddie 'Son' House, who started the Johnson story in the first place. And Son House would be a good place to begin: in this part-time preacher's music, the occult really never seems far away. To hear the naked groaning of House's 'John the Revelator' is to feel something of the awe and terror that the Book of Revelation is capable of inspiring. Hodgkinson mentions other such 'Faustian pacts':

> 'The blues player Johnny Shines held Howlin' Wolf in such superstitious wonder that he suggested that Wolf was a magic man who had done evil to get so good, and Tommy Johnson's brother LeDell told the folklorist David Evans that Johnson had said that the only way to get really good on the guitar was to go to a crossroads with your instrument a little before 12 at night and wait for a big black man to walk up to you and take your guitar. He will tune it up, play a piece of music and hand it back to you. After that you will be able to play anything you want, but you will also have a curse on you for ever more.'

This story is – as Robert Palmer, among the very best biographers of the Delta's music, notes – as 'old as the blues'. But devil or no devil, the lure of the Johnson story exerts a pull on the imagination that grows stronger over time. Like the crossroads stories – those myths lodged deep in an atavistic past – the idea of forbidden knowledge, and its unnatural trans-mission, is something too appealing, too strong, to put down.

Listening to any of Robert Johnson's recordings from the distance of over 60 years, do we get a sense

of the weight behind his work? As Palmer asks in his book, *Deep Blues*, 'How much history can be communicated by pressure on a guitar string?' To put on a CD now of, say, 'Crossroads Blues', from Johnson's first studio session in 1936, is to hear a rudimentarily amplified guitar working the chord progressions that make up the 12-bar blues back and forth, up and down, the strings being lashed, distorted this way and that; and a tenor voice coming in on a strangulated note, one quickly suppressed.

The recording, even allowing for all the compressions of modern digital technology, is scratchy. There is something slightly inert about it. It's identifiably a blues song – and perhaps it is so identifiable because one of Johnson's legacies to us is to make that 12-bar format recognizable – but it's not frightening. Its aura comes from what has been attached to the song rather than of the song itself.

The historian Marybeth Hamilton admits to a similar underwhelming experience on her first encounter with Johnson's voice. 'I heard very little, just a guitar, a keening vocal and a lot of surface noise,' she confesses. 'I certainly did not hear the tale of existential anguish that [music critic and cultural historian Greil] Marcus and others discerned within them. I wondered if this revealed some defect in me, or if there might be another blues story to tell.'[3]

Blues...

To be found wanting, incapable of the correct response, which like a depth charge detonates all the appropriate emotional reactions, is not an easy state to contemplate. Especially in regard to the blues – a subject that is now so large that it is far more than a music. Blues has become a shorthand for an emotional state, a place of dispossession and incomprehensible suffering.

Consider, from another continent, the wonderful Tuvan musician Sainkho Namchylak – the overtone or

throat-singer and composer whose breadth of experience spans folk ensembles and the extreme end of the avant-garde. She has been described as a Mongolian blues singer and indeed she has often referred to some of her songs as blues. Fado is often referred to as Portugal's blues, even if they have a more bitter-sweet flavor than that of Cesaria Evora and Cape Verde's *morna* 'blues'. The frenetic rhythms of klezmer, the East European dance music that is as much part of the Gypsy/Roma heritage as it is reminiscent of the pre-war Jewish community, is Balkan blues. Rembetika is the blues of Greece.

Even Alan Lomax, the ceaselessly inquiring US musicologist – and one of the first researchers to recognize the blues as America's 'most powerful, pervasive, popular musical form' – was happy to find in the music of the Italian *stornella*, the Spanish *copla* and the Mexican *corrida* a kinship with the blues. We can add Andalusian *cante jondo* – 'deep song' – and the basis of flamenco to the list. We come back to this point later in the chapter.

...Or not?

On the surface, there is something faintly absurd in this blues-extending process. None of the examples above have had any originating contact with either Africa or the Mississippi Delta, the crucible for the blues. The one exception to this is the singer Cesaria Evora, whose cultural location is at midpoints between her West African island home and the legacy of 500 years of Portuguese administration – Cape Verde attained independence only in 1975, soon after the fall of Salazar. And yet this is not to denigrate the music that Sainkho, the fadistas, the rembetes, and those Gypsies and the Jews who play klezmer produce. Each one is infused in its own virtuosities, its own histories and meanings, its own joys and sadnesses.

There is a poetic license in seeing – or hearing

– the blues the world over. Yes, it's true that deep emotions suffuse many traditions. Suffering is not the exceptional preserve of American blues, but there is a danger in detaching that sense of anguish from the Delta-bred music – for it takes something away from what makes the blues of Robert Johnson, Son House and the countless and unknown Afro-Americans singing in the fields and on the stoops of Mississippi, so unique and so potent that it has inadvertently provided a subtitle to so many completely disparate musical traditions. Just what is it about the blues that makes this music specifically what it is? It can't be that the blues – the Delta blues, that is – is somehow universally seen simply as the sole repository for songs of existential anguish.

'Suffering and hard luck were the midwives that birthed these songs. The blues were conceived in aching hearts,' wrote the African-American composer, band leader and blues musician WC Handy in *Father of the Blues* (1941). And yet there is no popular music of any kind that is as loaded as the blues is. The weight of a dispossession that has its roots in slavery, and the grind of rural poverty is also heavy in it. There is a caveat here: to reduce the blues to misery alone – a song form provoked by spells in the penitentiary, perfidious lovers and downright lonesomeness – is to strip it of its wider meanings.

Blues' birthplace

Robert Palmer's book makes an excellent job of tracing much of the method of the blues to its origins in the African territories that slave traders knew as Senegambia – that is, contemporary Senegal, Gambia and Guinea. The rhythms and repetitions, the calls and responses and even the instruments (the American banjo, for example, developed out of Senegambian lute or *halam*) of the 20th-century blues share a clear line of descent from their African forebears. Like the

earlier field hollers and the work songs, the blues is an echo of Africa as much as it is its own thing and in this way is an important forerunner of what we today call world music.

But there was also a strangeness in the blues that drew listeners in. Handy's description of a chance encounter in 1903 with a nameless guitarist one night at the railway station at Tutwiler, Mississippi, as he waited through the night for a spectacularly late train, is a famous one, but it encapsulates the elements of the uncanniness of the blues, of its unknowability, better than any other piece of writing:

> 'A lean, loose-jointed Negro had commenced plunking a guitar beside me while I slept. His clothes were rags; his feet peeped out of his shoes. His face had on it some of the sadness of the ages. As he played, he pressed a knife on the strings of the guitar in a manner popularized by Hawaiian guitarists who used steel bars. The effect was unforgettable. His song, too, struck me instantly.
>
> 'Goin' where the Southern cross the Dog.'
>
> The singer repeated the line three times, accompanying himself on the guitar with the weirdest music I had ever heard.'[4]

Alan Lomax

Weird, sad, fragile: the early musicologists who went looking for the blues knew this. They also knew enough about it to realize that the conditions which made the blues were changing fast. At the time that Alan Lomax, song-collecting for the Library of Congress, went looking for Robert Johnson in the mid-1930s, the Delta region was hemorrhaging its black population. Black sharecroppers had been abandoning the Delta plantations for opportunities in Chicago and elsewhere since the 1900s, but within

a decade of the end of the First World War, the flow had increased dramatically. Palmer quotes an estimate made by *Time* magazine in 1944 that 50,000 Mississippi Afro-Americans had left the Delta since 1940. The heavy industries of the northern cities offered jobs that, if not perfect, were steadier and safer than those on the old plantations.

Lomax never found Johnson; he and his colleague John Work were too late for that. But in 1941 in Stovall, Mississippi, he did find Muddy Waters, who played guitar, ran a juke house (a roadside café with music) and distilled his own moonshine when he wasn't driving a tractor.[5]

It is impossible to overestimate the significance of the song-collecting and musical advocacy that was Lomax's life-work. His enthusiasm for folk musics – from the Delta to the Caribbean to the ballads and singers of Scotland – surges from his books and recordings of lectures, radio programs and the like. For him, song-collecting was about more than simply the preservation of an oral tradition – although that played its part, and listening to modern-day versions of blues songs, one hears the debt. From the Animals' R'n'B hit, 'House of the Rising Sun', to Nick Cave and the Bad Seeds' rock updating of 'Stagger Lee', to Jackie-O Motherfucker's free-folk version of the sonorous 'Go Down Old Hannah' – a song addressed to the setting sun and one that Lomax heard sung, in all its spare power, by Ernest Williams in 1933 on the Central State Farm in Sugarland, Texas, and on many separate occasions by Lead Belly – it's hard to imagine whether or not these songs would even have a currency had it not been for collectors like Lomax.

Living histories

For him, these songs were living histories: music that was an integral part of a social, cultural and historical situation, and because of this, good historical records

were necessary. In the matter of strict accuracy, it's possible that Lomax might have been overzealous. His reportage, especially in conversing with those who speak with an Afro-American dialect, might be a faithful reflection of what he heard, but to modern ears, it sounds uneasy (see box **Iron Head**).

Some 30 years later, the song-collector would be taken to task by black activists, who, notes Ronald

Iron Head

Lomax is talking to Iron Head, 'a grim-faced man of about 65' in a Texan black prison farm, in the early 1930s. Iron Head, who has just sung 'Old Hannah', is resisting the exhortations of his workmates to sing another song. 'Goddam you big-mouth niggers, you know it wuk me all up to sing dat song,' says Iron Head. The song is one that takes its name from 'Shorty George', the prison train that brings visitors to and from the jail. A little later, Iron Head calls Lomax aside to say:

'I'll sing dat song right easy foh you, ef you want me. You know it bad fer me to sing it. Make me want to run away. I'm a trusty, got an easy job. Ef I run away, dey sho' catch me an' den dey put me in de line to roll in de fiel' an' I'm too ole fer dat kin' o' wuk. An' dat song make me want to see my woman so bad I cain' hardly stan' it no longer.' But he sang the song.

'Shorty George, you ain' no frien' o' mine,
taken all de women an' leave de men behin'
She was a brown-skin woman, mouth full o' gol',
An' I wouldn' mistreat her, save nobody's soul.
Dey brought me a letter I couldn't read foh cryin'.
My babe wasn't dead, she was slowly dyin'.
Dey carried my baby to be burying' groun'
You oughter heard me holler when de coffin soun',
I went to de graveyard, peep in my mam's face,
Ain't it hard to see you, mama, in dis lonesome place.'

Lomax comments: 'We looked closely at Iron Head. He was crying – "de roughes' nigger dat ever walk de streets of Dallas", crying. 'But your woman isn't dead,' [we said].

'She might as well be. I cain' go to her an' she scai'ed to come to see me.' ■

From Alan Lomax (with John A Lomax), '"Sinful' Songs" of the Southern Negro', American Ballads and Folk Songs, 1934.

D Cohen, 'found the older songs strange, smacking of slavery and oppression and Lomax's remarks patronizing'.[6] It must have been a hard moment for Lomax, whose support for civil (and workers') rights in the US was so thorough as to have attracted the notice of the FBI on numerous occasions.

It is possible that, were Lomax alive today, his song-collecting might have been done in a different manner, with a greater sense of self-reflection, an awareness of all that he himself might transfer onto the site of something that he identified as outside himself. But it is possible also to be too hard on him. He was fixed on the significance of the blues and its capacity to effect social change. 'The tremendous enthusiasm of all Americans, no matter what their prejudices for negro folk music, and the profound influences of this music in American culture – all this denies the effect of Jim Crow [segregation laws] at this level of communication,' he wrote.[7]

Music for justice

Music meant change; listened to, it meant justice. Lomax's activism was not confined to any single genre of music, but rather took a holistic view of creative productions. Founding a charitable organization, the Association for Cultural Equity (ACE), in 1983, Lomax defined cultural equity as 'the right of every culture to express and develop its distinctive heritage'. It is, in many ways, the apotheosis of Lomax's mission. Collecting, researching, giving notice of the 'expressive traditions of the world's people', ACE is no dusty ethnological backwater, but a recognition of the dynamics of culture. And this is something that still resonates in some of today's world music.

The dilation of interests that ACE represents can perhaps be seen as the mature conclusion to a lifetime's work. As far as the US was concerned, Lomax was doing something hugely important. He was, in

effect, creating an archive of American music. Even if the music he recorded, promoted and analyzed had its origins in foreign – African or European – traditions it still lived and evolved in its new homeland. It had become American and as such, it described America.

The importance of this cannot be overstressed in a country which, prior to the work of folk-gatherers like the Lomaxes (and, separately, Harry Smith, who collated folk songs from his 78rpm archive to produce the hugely influential *Anthology of American Folk Music* in 1952), had an uncertain relationship with what constituted American music. To identify and claim these living folk traditions was tantamount to the pronouncement of a cultural legitimacy that rested in the United States itself.

But if this quest for a national, cultural identity was a product of Lomax's work, it was not one that was at the fore as he worked. Preservation, representation, popularization, yes; but the presence of any wish to conduct a deeper investigation into the motives for such arduous searches is less clear. Arguably, the ability to hold up to scrutiny people's motives for searching out the blues is an activity that comes from a post-modern sensibility, a place that allows for a greater awareness of what we, as investigators, import into the subjects of our interest. Our own fantasies of

In search of the blues

'The voices of [Robert] Johnson, [Son] House, [Charley] Patton and [Skip] James were pushed to the foreground not by black record buyers, but by more elusive mediators and shapers of taste. Underpinning the rapturous acclaim for the music's "almost archaeological purity", its "rough, spontaneous, crude and unfinished" voices, is the legacy of those mediations, an unspoken conviction that what we are hearing is uncorrupted black singing, the African-American voice as it sounded before the record company got to it.' ∎

From Marybeth Hamilton, *In Search of the Blues: Black Voices, White Visions*, p 9.

the other, projections and transferences of feeling that insert ourselves into new tableaux – these are all suitable issues for auxiliary inquiries. Was Lomax motivated by what Stephin Merritt described in Chapter One as 'the very toothlessness and octogenarianess' of the people he recorded? Merritt was making a deeply sardonic joke, but there is also a deeply serious point behind it.

What lay – what lies, for it continues still – behind the searching, is the subject of Marybeth Hamilton's 2007 book, *In Search of the Blues* (see box p 110). It is a book that turns an inquiring gaze on those whose appreciation of music is inarticulate and unconsidered. It introduces us to the song-collectors (not only the Lomaxes, but genteel characters such as Dorothy Scarborough and Howard Odum), the record labels, the politics of Roosevelt's New Deal, and civil rights; even the Beat movement and Norman Mailer's wild-eyed characterization of the black man who lives in the 'enormous present... and in his music... gave voice to the character and quality of his existence, to his rage, and the infinite variations of joy, lust, languor, growl, cramp, pinch, scream and despair of his orgasm.'[8]

Hamilton's big theme is the purity of the blues, or rather, the imaginings of a pure music in the minds of those outside the blues. 'I am less interested in their' she refers to a list of blues searchers – 'discoveries than their fears and obsessions. All were captivated by the idea of (in John Lomax's terms) "uncontaminated" black singing...' Their 'investment in purity' has tangled their own histories with that of their subjects, and the tragedy was that they could not see this. Even Lomax is not immune. 'History has not been kind to Alan Lomax,' Hamilton writes. '...What emerges is a portrait of a ruthless, exploitative tyrant who paraded Lead Belly on stage in his prison stripes and enriched himself on his humiliation.'[9]

Looking for the blues

Familiar songs

But there are softer and sadder moments, too. Blues historians such as Scarborough had a personal invest-ment in the South and black songs are homely, famil-iar ones; they are soundtracks to individual reveries. These people remembered not the ways in which the black population was brutalized or disenfranchised, but balmy evenings and fond family servants.

In one haunting passage, Hamilton recalls a visit that Scarborough, born in 1878 and transplanted from Texas to New York, made to an elderly eminent surgeon in Manhattan. John Allan Wyeth (1845-1922), who had joined the Confederate army at the age of 17, was a Civil War veteran. His family had owned slaves and his earliest memories revolved around being dandled in the lap of one slave called Mack. Wyeth had been raised on the family planta-tion in Alabama and his own personal soundtrack to his early life – as detailed in his memoir, *With Sabre and Scalpel* (1914) – contained slave songs and dances. Wyeth tells Scarborough about one old man, Uncle Billy, who was a much-loved figure for the young boy. Uncle Billy – does he have another name? we are not told – is a former slave; he teaches young Wyeth to play the banjo, he guides his fingers over the strings. And then Billy, who stays loyal to his Confederate master, is dead, his throat cut by a black soldier from the Republican side. Wyeth gets out his banjo and plays some old songs for a captivated Scarborough, as recorded in Hamilton's book:

> 'And then, in the dwindling light, the old doctor rose to his feet and tossed aside his cane. He wanted to show Scarborough some of the old breakdowns, the way that the slaves themselves had danced them, so slowly, gingerly, he began moving his body as Uncle Billy had taught him to move. He clapped his

hands, bent his knees, clicked his heels and patted his thighs; he hopped and shuffled and kicked his legs skyward and hopped and shuffled and kicked again. As Scarborough watched, the surroundings faded, the tasteful décor and the expensive furniture and the roar and screech of the traffic below. Dr Wyeth jumped and twirled. "I felt transported," [Scarborough] wrote years later, "to the old plantation of days before the war."'[10]

This is an extraordinary anecdote. Wyeth and Scarborough's version of the South, of slavery and its aftermath, is paternalistic and – it must be said – utterly delusional. And yet, in Wyeth's dancing, there seems to be little of the parody of black music that was found in black-face minstrel shows, those peculiar deracinated race acts that were popular in the US and UK until comparatively recently. (Laura Ingalls Wilder's book *Little Town on the Prairie* contains one astonishing account of such a performance.) There is instead a real love present, a hugely problematic love, but a love nevertheless.[11]

Blues' legacy

Of all Alan Lomax's theories, the one that the blues, like most musics, is a developing one – that it had origins, present and future forms – is the most important. To see this requires the capacity to take a long view, and not get stuck in a restricted timeframe, with all the limitations that implies. Son House and company are no longer with us, but the Delta blues survives, and not simply as a recorded entity. Some blues has transformed into other things – R'n'B, Elvis Presley (a genre in himself), soul music, the rock music of the Rolling Stones, Led Zeppelin, more recently, the White Stripes.

Hip-hop has elements of the blues. In the ancestral

genes of the musics of the Caribbean, from reggae to merengue, calypso to mambo and bomba, there are the same African origins that are shared with the American blues. There are many others. Iconoclasts like Jimi Hendrix shredded traditional blues songs such as 'Hey Joe' and wrought new things out of the tatters; the performance poet Patti Smith's version of the same song dilated it into a vision of ecstatic freedom that carried the Symbionese Liberation Army and Patty Hearst in its wake. The shame (for some Afro-Americans at least) that was once attached to the blues – the music that sang out the bleakness of the American black experience – is all but memory. There are now hundreds of ways to play the blues today, and Delta blues is just one of them. As Will Hodgkinson found out at the Clarkesdale crossroads, Robert Johnson or Son House are no longer there. Like the ciphers they have become, they have moved on.

Today's blues

Go looking for the blues nowadays in any record shop and likely as not the seeker will be sent straight back to Africa itself – putting the world into world music. Racks of recordings from bands and musicians such as Tinariwan, Bassekou Kouyate and Ngoni Ba, Terakaft, Toumast, Etran Finatawa, Boubabcar Traoré, the 'songbird of Wassoulou' Oumou Sangaré, the late guitarist Ali Farka Touré and his son Vieux Farka Touré, the kora maestro Toumani Diabeté, Juldeh Camara, Rokia Traoré all testify to the fact that the blues is alive and well and thriving in Africa. Get hold of any one of these artists and a good time is guaranteed. Featuring many of the above artists, the Rough Guide's sampler *African Blues* is a good CD to start with, and it also has some fantastic pairings, chief among them Ali Farka Touré with the Virginia-based 'rasta blues' guitarist Corey Harris.

There is an enormous variety of experience

contained in these musicians. Juldeh Camara, singer and virtuoso player of the one-stringed fiddle called the *ritti*, hails from Gambia. Tinariwan, Terakaft and Tidawt are nomadic Tuaregs from the southern Sahara with Malian passports. Toumast's founder, Moussa Ag Keyna, comes from a valley between Niger and Mali and was caught up in the political struggles in that region for Tuareg independence. The musicians in Niger's Etran Finatawa divide between two nomadic groups, the Tuaregs and Wodaabe. Toumani Diabeté, the two Farka Tourés and Bassekou Kouyate and his band Ngoni Ba are from Mali. Boubabcar Traoré is from the Bambara region of Mali as is Rokia Traoré, the daughter of a diplomatic family.

Co-operation

Often these artists crop up in all kinds of collaborative sessions: Camara with British guitarist (and Tinariwan producer) Justin Adams; Rokia Traoré with the Kronos Quartet; Toumani Diabeté with both the Icelandic art-rock singer Björk and the veteran New York blues guitarist Taj Mahal; Tidawt with percussion expert Mickey Hart, formerly of the Grateful Dead, and projects involving the Rolling Stones.

Often West African music interconnects with other traditions to bring about the realization that cross-fertilization has been around a long time. Toumani Diabeté's superb *Mandé Variations* is one example. An album for the solo kora (a harp built from a large calabash gourd that acts as a resonator), there are points where the delicately produced overtones hang in the air like separate vocal lines reminiscent of the American classicist Steve Reich – who, incidentally, studied percussion in Ghana with Gideon Alorwoyie, and whose 90-minute work *Drumming* (1971) is directly influenced by that experience.

Many of these artists come from the traditional caste of *griots*, the hereditary musicians who are

common not only to Mali, which borders Algeria in the north and Guinea to the south, but also to Senegal, Gambia and Western Sahara. This area is roughly the same as the Senegambia region from which many people were taken into slavery.[12] These musicians are steeped in the localized, musical traditions of their cultures just as they are exposed to the globally prevalent musics of the rich world. It is fascinating sleight of musicology – and perhaps, musical justice too – to think of Ali Farka Touré's roots and blues guitar music as perhaps the homecoming of the blues, a return to an almost prelapsarian purity. Yet, to envisage a blues unmediated by anything other than perhaps itself, is to fall into the same trap as the blues hunters detailed by Marybeth Hamilton.

'Nomadic blues'

There are many merits of these new-old transmissions of the blues, and taken jointly or separately many of these musicians are producing some of the most vital sounds and ideas in contemporary world music. Yet to repackage them as the blues is to wrap them in a meaning that obscures more than it enlightens. Much publicity surrounding the Tuareg bands emphasizes their 'nomadic blues'. There is a nice ring to the phrase. It is nice to imagine Tinariwan, co-founders of the Festival in the Desert, playing under the desert stars on their stage in Timbuktu. But then one thinks, too, of what 'Tuareg' has come to mean. When Volkswagen markets a rugged (but not too rugged) car named Touareg [sic] ('tackles the roughest terrain with ease'), presumably to pander to buyers' fantasies of the romantic nomad and of travel that is a bit (but not too) challenging, one detects the manufacture of new stereotypes.

Blues has traveled back to Africa and in doing so has engendered for many of its listeners new imaginings of journeys and faraway places. But this at least

allows for the possibility of outward travel, of actual locations. In the next chapter, it is the inner journeys that are considered.

1 The musicologist Alan Lomax relates that Morton died in the arms of his mistress, calling for holy oil to 'cheat the devil' of the bargain. Whatever the truth of the story, the satanic rumors weren't enough to stop Morton getting a send-off with a high mass in New York's St Patrick's Cathedral following his death. 2 Alan Lomax's anecdote is reprinted in *Selected Writings 1934-1997* (Routledge, 2005). For more on crossroads myths specific to the American South, see Harry Middleton Hyatt's researches made between 1936-40 and collected in the five-volume (and hard to find) *Hoodoo, Conjuration, Witchcraft and Rootwork* (self-published, 1973). Hyatt, a retired clergyman, interviewed 1,600 African-Americans to compile over 13,000 spells and stories. The website Lucky Mojo – www.luckymojo. com – reproduces a few. 3 Marybeth Hamilton, *In Search of the Blues: Black Voices, White Visions* (Jonathan Cape, 2007). 4 Both Handy quotes are taken from Hamilton, ibid. 5 Musicologist Alan Lomax (1915-2002) is a pivotal figure in American music. He was a tireless collector of folksongs from many traditions and was, inter alia, responsible for bringing Woody Guthrie to greater notice. With his father John, Alan Lomax had earlier collected many early blues and what they termed 'negro work songs', including ones by Lead Belly (Huddie Ledbetter) in 1933, who was working on the Angola prison farm in Louisiana serving a sentence for murder. The Lomaxes traveled with a 350-lb Presto recording machine in the back of their car. Lomax recorded important interviews and sessions with such artists as Jelly Roll Morton and musicians from many other traditions besides the blues. He is an enormously important person in the surge of popular interest in American folk music that started in the 1950s and continues to the present day. Many of Alan Lomax's song collections are released in a huge – and hugely recommended – series of albums by Rounder Records. 6 From Ronald D Cohen's introduction, 'The Folk Revival (1960s)', in *Alan Lomax: Selected Writings 1934-1997*. 7 Gene Bluestein, *The Voice of the Folk: Folklore and American Literary Theory* (Amherst, 1972). 8 Norman Mailer, 'The White Negro', quoted in Hamilton, op cit, p 194). 9 Hamilton, ibid, p 109. 10 Hamilton, ibid, p 44. 11 John Allan Wyeth's *With Sabre and Scalpel: the Autobiography of a Soldier and Surgeon* is online at http://docsouth.unc.edu/fpn/wyeth/wyeth.html. The book contains some anecdotes about Wyeth's childhood memories of black music, including lessons with Uncle Billy. It is an alarming book, chiefly because of its attitude to slavery and the benign goodness of both white families and faithful retainers. And yet the complicated emotional ties between the young Wyeth and his slave 'mammy' ring true. 12 Contemporary Mali is also home to many other significant musicians – Salif Keita, Habib Koité and Amadou and Mariam among them – whose work is not within the wider definition of blues.

5 Lost in music: ecstatic visions

'We're lost in music/ Feel so alive/ I quit my nine to five/ We're lost in music.'

Sister Sledge, *'Lost in Music'* (1979).

Dancing with the dervishes... The lure of other worlds... The atavistic nature of cheerleaders.

TO SPEND THE hours after dark on Marrakech's Djemaa el Fna is to spend time with a hubbub of humanity that has probably changed little in the many centuries that have washed over this spacious square at the heart of the ancient Moroccan city. True, there are more tourists here than there used to be, but the Djemaa el Fna, situated at the end of a long and dangerous road winding northwards from the Sahara Desert, is not unused to travelers from foreign lands. The musicians, the singers, the magicians and snake-charmers, astrologers and acrobats, dentists, leech-doctors, numerologists, sorcerers and herbalists of the square wait for them as much as for the more familiar peoples – Berbers, Africans, Arabs, the nomadic Tuareg (or blue men, so-called because of their indigo-stained skin) from the desert.

In some ways Djemaa el Fna is a focus for a world of music. The music performed has long exerted a powerful pull. It's entertaining: musicians squat down on the ground to play and crowds encircle them. At night, illumination is limited to portable lights that each musician or mendicant brings and beyond the glow the blanket of inky blackness surrounds the square. In daylight the views of the distant Atlas mountains add to the spectacular nature of the place. Steam from food stalls offering couscous, meat and vegetables stewed in tagines, also snails and grilled meat, floats upwards. But amongst all this, there is some serious business at hand. The Djemaa el Fna is also the place where Sufi brotherhoods of musicians congregate

and play music with the aim of both drawing nearer to God and spiritual ecstasy. While some of these ceremonies are performed in private, others are not, especially those conducted during special celebrations (*moussems*) devoted to the favored saint of the brotherhood in question.

There is music for healing, music to meditate on God or a particular saint. There is music whose hypnotic rhythms and repetitive chants (often riffs on the name of Allah or the holy men sacred to each brotherhood) is intended to induce trance states in both performers and listeners – it is music to get lost in, or rather, music in which to lose the distractions of the world. Musicians from established Sufi sects come from all over Morocco to the square – the Hamadacha, Jilala, Aissawa, originally from Meknes, and Derkaoua are there. So are musicians of the Gnawa, an ethnic group who have descended from either African travelers to northern Africa or from former slaves. All the brotherhoods practice a rhythmical, hypnotic music. Skin drums, *ouds*, *gimbris* (a kind of flattish three-stringed lute, also called the *sintir*), flutes and chants are used. In Gnawa music, the gimbri player is also the *ma'alem* or master of ceremonies, the one who sings out short vocal lines for his comrades to repeat. For one Moroccan Jilala group, the Rokia Riman Jilala Band, drumming and chanting is used to induce trance states in women

Djemaa el Fna

'In a world where information technology is homogenizing our lives, confining us in the remote-controlled darkness of privacy, the Djemaa el Fna offers a stark contrast – a public forum that fosters human interaction through its music, furthering the ancient oratory traditions and vibrant human communication created by its poets, musicians and storytellers.' ■

Hisham Mayet, *Musical Brotherhoods from the Trans-Saharan Highway*.

who visit the band for healing purposes. This is music with a purpose, and if there is anything frivolous in it, it is to do with the joy of God.

Seeing the music

While there are numerous recordings, many of them excellent, of Morocco's trance music, decent films of music performed on the Djemaa el Fna are harder to find. Steven Montgomery's short documentary, *Morocco: the Past and Present of Djemaa el Fna* (1995), provided one atmospheric pathway through the square's many facets, but in general, any effort to represent the totality of what the Fna is about each night is a daunting one.

The main exception to this is an hour-long DVD documentary directed by Hisham Mayet, the

Musical brotherhoods

In his film *Musical Brotherhoods from the Trans-Saharan Highway*, Hisham Mayet packs plenty in as his camera moves between the various pools of light on the Fna. There's an earnest male soloist; music from some Hamadacha players; some cross-dressing belly-dancers prancing about and, surrounding a taut-looking man with a tatty old oud, the Troupe Majidi. This all-male group is the unalloyed highlight of Mayet's film and as good an example as any of what happens when music, rhythm and a state of mind come together. At first, it's possible to think that the oud player is the one who controls the music that they're playing. He has an electric pick-up fitted to his instrument and, connected to that, some rudimentary amplification, all the better to transmit the lightning quick streams of notes that he sends out into the night. It's the oud man who opens this piece of music and, much later, sets the pace to bring it down to earth again. But watch and listen more closely, and there's another man whose low-noted frame drum picks up a beat and signals it to his cohort of younger men, waiting ready with a battery of frame drums and tom-toms. A stately pace is established and after a few minutes, the men chant a melody in unison. Time passes and, as the oud peels away into near silence, the drums go off – rhythmically, frenetically, at a sprint speed, and all the while kept to a time by the one, low-noted drum. Finally, that first drum and the oud bring proceedings down to earth and the intensity is slowly released. It is a remarkable sequence to watch. ■

co-founder of the US-based record label Sublime Frequencies. *Musical Brotherhoods from the Trans-Saharan Highway* is nothing short of captivating. Mayet practices what Sublime Frequencies preaches across its eclectic catalogue of releases – namely that any editorial presence is pared down, almost to the bone. Other than the choice of footage that goes into *Musical Brotherhoods*, the editorial intervention is minimal. There is nothing flashy about the DVD; they are produced in limited numbers; no snazzy packaging, extras footage or liner notes, just an hour of street music filmed partially in the coastal town of Essaouira and mostly on the Djemaa el Fna.

Electric amplification and pick-up excepted, the music of the Troupe Majidi (see box **Musical brotherhoods**) is ancient. Their words and instruments are particular to their own Moroccan connection, but their search for an ecstatic communion created by music is one held in common by many cultures and different traditions from all over the world. Shamanic ritual music exists in Tuva, Mongolia, in Tibet and in the *gamelan* music of Indonesia.

It is in the Italian tarantella, a dance once linked to the bite of the tarantula spider in the south; the voodoo music of West Africa and Haiti; *candomblé* in Brazil, and ritual musics from indigenous peoples in Australia and Oceania, the San in Namibia, the Raramuri in Mexico and the Sámi in Lapland and northern Scandinavia. Among many Native American nations including the Apache and the Navajo, ritual practitioners, who have memorized hugely long sequences of song cycles, use chanting and rattle-based music to access an otherness – a state of conscious necessary for the purpose at hand. The same search is present in electronic club music (in which, since the mid-1980s, a drug not coincidentally named ecstasy played a part), where DJs ramp up records to at least 120 beats per minute. Upwards

of 130bpm is now the rule for club trance music.

Sufi music

As the popular, mystical form of Islam, Sufism is by no means confined to Morocco. It has millions of followers all over the world, and not all of them Muslim. As with Tibetan Buddhism, many people outside any Islamic context have been drawn to Sufi teachings and practices. Sufism originated in what is now Turkey, via the writings and teaching of its founder, the 13th-century poet and mystic Jalaluddin Rumi, whose shrine is in Konya, Turkey. As a route to God, Rumi's practice was not an austere road:

> 'Come, but don't join us without your music.
> We have a celebration here.
> Rise and beat the drums...
> We are drunk but not from wine made of grapes...
> This is the night of the *sema*, when we whirl to ecstasy.'

Even though the more puritanical sects within Islam abhor music, it is an art form that is, unsurprisingly, well represented in Sufi devotional practice. The great Pakistani *qawwali* (devotional music) singer Nusrat Fateh Ali Khan, who died in 1997, was a Sufi and to listen to his improvisations is to be in the presence of an elegant and lissome musical intelligence, as themes, motifs, intensities are created and diminished. Similarly the great man's nephews – Rizwan Mujahid Ali Khan and Muazzam Mujahid Ali Khan (who record as Rizwan-Muazzam Qawwali) and Rahat Fateh Ali Khan, the latter being Nusrat's formal heir, a celebrated singer in his own right, who has described qawwali as the 'music of the soul'. So are the Mevlevi brotherhood, also known as the whirling dervishes of Turkey.

Further afield

Senegal's Youssou N'Dour has been inspired by Sufi teachings. Sufism is celebrated in the bhangra pop of Lahore's Junoon, the rock band led by Salman Ahmed, and also the club music of Mercan Dede, whose fusion of electronic beats and traditional Turkish Sufi music has propelled the DJ and *ney* player into an international limelight. One woman, Abida Parveen, is a celebrated example of a female singer who has taken on the deeply conservative milieu of the Sindh, her province in Pakistan, to establish herself in the first rank of the world's Sufi musicians. And Sussan Deyhim, the New York-based singer, is a composer whose work stretches from the Persian classical music of her Iranian background to the experimental stream within art music and film. Deyhim's Madman of God (Cramworld, 2000), an album of music based on poems by Sufi writers such as Rumi and Hafez – what Deyhim calls the 'torch songs of classical Persian music'– is a celebration of the ecstatic.[1]

While the desire to use music to access something beyond the immediate is a feature of many cultures, there has long been a fascination within Morocco's contribution to this area. The American composer

Sussan Deyhim

What can someone who knows nothing of Sufism and who's never been to Iran understand from your work?

'What do I care? I don't care what someone's judgment is about the way I should be presented or the reality of my depth or whether I'm degenerate or not; punk or monk; sacred or blasphemous... I'm trying to find a balance between Sufism and me... We should all have a dignified identity based on not where you come from, but who you are as a soul. That transcends cultural barriers and parameters of wherever you're from. Things are subtler than we give them credit for. You know why? It's a lot harder to deal with subtle things. Subtlety requires interaction.' ■

Sussan Deyhim, speaking to Louise Gray, 2000.

and author Paul Bowles[2], a former student of Aaron Copland, with connections to many European/US avant-garde figures such as Gertrude Stein, had settled in Tangiers soon after the end of the Second World War. As a musician and musicologist, he became interested in the music produced by the Gnawa, Jilala and, from a mountain village near Fez, Jajouka. Like Lomax, Bowles also recorded local music for the Library of Congress.

Soon after Bowles' arrival, another expat artist, the Briton Brion Gysin, arrived. Gysin, who opened a restaurant in Tangiers, was soon captivated by the music of the Joujouka and in particular, the festival of Boujeloud, a local celebration with its origins in pre-Islamic folklore. Boujeloud, which is held at the end of Ramadan after the feast of Aid el Kebir, lasts a week and involves drumming, high-pitched, split-reed horns called *rhaitas*, lutes and flutes, the smoking of quantities of *kif* (the local hashish), a dancing man – Bou Jeloud himself – sewn into a goat's skin. And music – beats repeated for so long that new reserves of stamina are summoned and new stages of consciousness invoked – are all part of the festival's appeal.

Today, the feast of Boujeloud is world-famous, but for the expats the celebration was like stepping back into the archaic past. Gysin, who was taken to his first festival by the local painter Mohamed Hamri, believed that what he was seeing in Boujeloud was nothing less than a contemporary manifestation of the rites of Pan. He speculated that he had stumbled into a preserved version of Lupercalia, the fertility festival that was celebrated by Roman, and before them, Greek, shepherds and farmers, and which featured the god Pan.

Spread the word
Gysin told his friends, a list of whom read like the who's who of the post-war counterculture. LSD guru

Timothy Leary came; the writer William S Burroughs came and pronounced the music 'the primordial sounds of a 4,000-year-old rock 'n' roll band'; Brian Jones of the Rolling Stones, who visited Jajouka at a time when most of his fellow-travelers were heading off to India in search of *raga* trances, liked what he heard so much he recorded an album of the Master Musicians of Jajouka in 1968 – *Brian Jones Presents the Pipes of Pan at Jajouka*. Originally released by the Stones on their own label, the album was so influential that others, Ornette Coleman[3], Richard Horowitz and Bill Laswell among them, were gradually drawn into the party.

With supporters like this, Jajouka could hardly fail to generate interest in those interested in psychotropic music – even if there was a series of acrimonious fallings-out between the musicians after the appearance of their famous friends. There are now two groups of master musicians, with each group favoring its own transliteration from Arabic to Roman text. The 'Joujouka' side of things is currently looked after by Hamri, the artist who had led Bowles and Gysin to the village in the first place. The other side – the 'Jajouka' – has as its leader Bachir Attar, who is the son of the musician who led the musicians in the 1960s. Recordings featuring both sets are readily available; a more recent recording of Boujeloud music has been released by the Master Musicians of Joujouka (that is, the first group) on Sub Rosa Records.

Entranced

The enthusiasm with which Morocco's trance music has been greeted in the wider world is undeniable. From the brotherhoods to all the master musicians of Ja/oujouka, these are fine musicians, with the subtlety to create and carry the surges of excitement that they create for their listeners, especially those who witness them live – in the contexts in which the music has

a wider meaning. But there are also other issues to consider in the translation of their practice from one culture to another.

Historically, trance music has arisen out of sacred or shamanic practices. Made international by a combination of personal advocacy, genuine cultural interest, tourism and the simplicity of digital technology, it now reaches wider and more varied audiences than the first man who dressed up as Bou Jeloud ever envisaged. And because of its repetitive nature, ancient trance music lends itself to re-use within modern club contexts.

This creates a curious situation. Trance music, until the last decades, has always been used to dealing with specific purposes. These have been particular and individual circumstances – healing ceremonies or the contact of spirits in extra-human realms, for example. They have a unique communal and philosophical context. To consider trance music now – or at least how it is generally understood – is to talk about club culture, about electronic trance music, about a development of the acid house and techno that exploded into public consciousness in 1987. Where do the rites of the Gnawa, the Joujouka and their confrères the world over fit into this?

In two ways. The first is that, just as the ceremonies of Gnawa, the Joujouka and others are communal ones, so too, is the performance of trance music within the club setting. Acid house was a genuinely ecstatic music. Not because it was fueled by drugs (although ecstasy, the generic name for MDMA, played a significant role), but because in the hands of adept DJs and producers the music could lift its listeners to a new level. They both have a metaphysical aim of a communal good, in that benefits are transmitted to a wider community – even though this might be expressed in different ways. The healing rituals of, for example, the Jilala Band, are understood as practices

that seem to remove a symptomatic pain and to do good. For the dancers at Shoom, Rave in Peace (RIP) or Hedonism – to take the names of three of London's most influential house clubs in 1988 – a peacefulness, with all the social benefits that that implies, was part of the experience. At least I thought that there in 1988 and, 20-odd years later, I still think so.

Adapting to new settings

There is a second route, too, which involves the ways in which practitioners of traditional trance musics have adapted their art to new situations. For the 'overtone' singer Sainkho Namchylak, the distinctive singing methods that she learned in Tuva, a republic of the Russian Federation that lies just north of Mongolia, have been applied in new circumstances.

Sainkho – as she tends to be called – was trained in Tuva's folk traditions and specifically *khöömii* – a kind of throat (or overtone) singing that is capable of producing more than one 'voice' at any one time. The technique is found in many other traditions, Tibetan music being one of the most renowned examples. To experience overtone singing is to hear something quite unearthly and thrilling and so it follows that khöömii is a technique that has long been endowed with a shamanic power. And in a land where extreme winters and long journeys (Tuva, like Mongolia and surrounding provinces, has many nomads) are the norm, good contacts with the spirits of gods and nature can do no harm. They are reached via a repertoire of cult songs.

'It's a much more ritual type of music, more sacred,' Sainkho told writer Roberto Gatti on the occasion of the release of *Naked Spirit* in 1999. 'Within it are greeting songs or songs for the spirit (that of men and also nature), shamanic songs, simple melodies which are to be repeated *ad libitum*, like real mantras, and at last, lamanistic songs, which refer to Buddha and to the hundreds of bodhisattvas which populate our

region. Personally, I must say that the songs belonging to the cult music are those which give me the most gratification, because when I sing them I try to create a connection between earth and sky."[4]

The repertoire of the Tuvan bands that have come out to greater notice reflect this. Huun-Huun-Tu, Yat-Kha and Shee-De are all bands whose music is in step with the natural world. On Huun-Huur-Tu's 2008 album, one which features Sainkho herself, *Mother-Earth! Father-Sky!* (the title is inspired by an ancient Tuvan prayer), the inspiration is folk song, even if their verve gives them room for making the material their own.

While the tape loops and cut-ups on Sainkho's subsequent album *Stepmother City* (Ponderosa, 2000), veered towards a Björkish territory that was more clubbable, she has always brought traditional methods to contemporary ends. One example of her work at the most experimental end of the vocal spectrum is the tracks she contributed to Nina Danino's 1998 art film *Temenos*.[5] A film work concerned with the genius loci of religious manifestation, Sainkho appeared alongside avant-garde vocalist Shelley Hirsch. The two singers come from completely different vocal traditions, but they both put improvisation at the heart of their practice and the results – an access to a palate of color, microtones and timbres – are very similar.

Turkish roots

Where some traditional practices have their roots in religious beliefs that do not always tally with more authorized versions, they have to some extent been rewritten as folkloric performance. This has happened with the whirling dervishes in Konya, the Turkish city that houses the tomb of Rumi. The four-part *sema* ceremony of music and whirling that visitors see here is one that is detached from its original religious context. In this case, the reason is political: following

the collapse of the Ottoman Empire, the new Turkish republic which replaced it in 1923 was – and continues to be – fiercely secular.

What were perceived as 'Eastern' traditions were eradicated in favor of a more Western-orientated and 'modern' approach. For example, republican Turkey changed its writing script from Arabic to Roman alphabet. Western classical music was promoted at the expense of Turkish – that is, Ottoman – and various folk traditions. One deeply unpopular plank of the new government's modernization agenda was the substitution of Turkish as the language for the Islamic call to prayer. (It was changed back to Arabic in the 1950s.)

Sufism in Turkey was suppressed, its *tekkes* (meeting halls) closed and its adherents imprisoned. The practice continued, albeit very much out of sight. Even today, Sufis display some trepidation about how open they can be in their display of faith and culture. During the course of filming the highly informative documentary, *Sufi Soul: The Mystic Music of Islam* (Riverboat/World Music Network DVD, 2008), writer William Dalrymple and director Simon Broughton visit an ordinary flat in the suburbs of Istanbul where a group of Sufis – musicians, too – are meeting. Unlike many other Turkish Sufi groups that the film crew contacted, this brotherhood had agreed to appear on film. 'No-one's been arrested for one of these ceremonies for years,' Dalrymple notes, 'but there's still a nervousness in Turkey about openly being a Sufi.'

Islamic praise singers

A similar process is affecting Zanzibar's Islamic praise singers. The *Maulidi ya Homu* practice an old form of worship, which includes chanting (in Arabic and Swahili), drumming (in some cases, on old tins) and a focused choreography – swaying and delicate hand gestures – which one spectator of the Mtendeni group

compared to 'live coral' or 'rolling waves'. It is believed that there are only a few maulidi groups currently active: the Mtendeni group is the most famous, traveling internationally and appearing at numerous festivals. Farhan Mussa, a group member, believes that although the maulidi's songs are focused on Allah, the reason that they are tolerated is because they do not interfere with organized religion. Describing them as a folkloric experience is a neat way of sidestepping potential clashes.[6]

It would be crude and wrong to believe that trance music is the preserve of cultures and religious practices that fall outside those of the rich world. But the impulse towards an ecstatic otherness is not one confined to the phenomenon of club music. It is present in the rhythmical glossolalia (or speaking in tongues) that characterizes some Pentecostal and charismatic traditions within Protestantism.

Under another name, Dionysian, it is also to be found within certain fine art practices, in the slabs of mechanical rhythms thrown out in the performances of Linder[7], provocateurs Throbbing Gristle and Psychic TV; the tintinnabulation of Charlemagne Palestine, and most notoriously in the work of the Austrian actionist artist Hermann Nitsch. A hugely controversial artist, Nitsch's six-day-long *Orgies Mystery Theater*, staged at his home at Schloss Prinzendorf in eastern Austria in 1998, was the culmination of decades of work. Described as a Dionysian cathartic ritual, it featured animal sacrifices, priestly performers and music. A live recording of some of the performance was later released in a boxed edition of 51 CDs. At certain points, one can hear the dissenting voices of Prinzendorf's residents rising over the sounds of the performance.

Access for all?

Can listeners who come from outside the tradition of a foreign trance music access the ritual in the same

way that a more local and presumably adept population is able to? There is a telling passage in Umberto Eco's 1989 novel, *Foucault's Pendulum*[8], in which a group of unbelievers visits an *umbanda* ritual in Brazil. Umbanda is an Afro-Brazilian syncretic ritual that fuses elements of Christianity with vestiges of Yoruba practice in the dance, a ceremony where some participants are said to be possessed by various divinities – Exu, the psychopomp and god of crossroads, and his feminine counterpart, Pompa/Pomba Gira, for example – or the *egun*, the spirits of the dead. Among the visitors there is Amparo, a secular, 'modern' Brazilian woman and the lover of one of Eco's protagonists:

'I saw [Amparo] fling herself into the midst of the dancing, stop her abnormally tense face looking upward, her neck rigid. Then, oblivious, she launched into a lewd saraband, her hands miming the offer of her own body. "A Pompa Gira, Pompa Gira!" some shouted, delighted by this miracle. Since until then the she-devil had not made her presence known. O seu manto é de veludo. Rebordado todo em ouro, o seu garfo é de prata, muito grande é seu tesouri... Pomba Gira das Almas, vem toma cho cho...'

Amparo finally comes to. 'How embarrassing!... I don't believe in it, I didn't want to. How could I have done this?' she says.

Eco, himself an adept in the mysteries of the semiotic and the whole querulous issue of how narratives are constructed and deconstructed, is not a believer either. *Foucault's Pendulum* is not so much a novel about the occult as one on the occult – in particular, its self-perpetuating ways and, for would-be initiates, the carrot of arcane knowledge. But the issues that Eco's

literary evocation of an umbanda ceremony touches on are multiple: the clash between the 'modern' and the 'archaic' mindset; the unconscious wish to relinquish personal control; the desire to express or act out that which is otherwise unexpressed; our individual susceptibility to a category of behavior collected under the term of mass hysteria. The action of collective emotion upon the individual psyche is a powerful one. It is not predictable, as Eco's Amparo discovered, who can resist it. Trance states may not always have their genesis as a symptom of mass hysteria, but there are links and equivalences.

Visions

There are caveats. A trance induced by club music is not, as far as anthropologists or ethnomusicologists are concerned, the same as one created via shamanic ritual, no matter how eloquently Sister Sledge's timeless hymn to disco, 'Lost in Music', puts it. Clubbers do not routinely see visions (unless the drugs are very potent) and they don't go looking for contact with gods or ancestral spirits. While the creators of modern dance music habitually raid shamanic music in order to make recordings for club consumption – it's not uncommon now to hear a snatch of Native American drumming or qawwali on a dance record – the ethics of using sacred music for popular purposes are dubious.

Even the recording of sacred music can present problems: in one case, many Native Americans were concerned that tapes – for public sale – had been made of the sacred ritual of the sun dance in South Dakota in 1989. To detach the music from its greater context was, it was argued, akin to an act of desecration.

In a world where so many traditional practices belong to a minority culture surrounded by an immensely powerful dominant one, such objections must be taken seriously. In Canada, there are moves

to bring many aspects of aboriginal cultures, including music, performances and traditional patterns, under the protection of legislation pertaining to intangible intellectual property. Other administrations, including the federal government in Australia and UNESCO, via its division of cultural heritage, have made similar sympathetic moves. The protection and continuation of traditional musical expression starts with the acknowledgement of their fragility in the globalized world.

From 'primitive' to popular

Nevertheless, contemporary interest levels in ecstatic music are high enough to suggest that the dominant Western culture has changed its tune on the subject. In *Dancing in the Streets*, Barbara Ehrenreich details the reactions of so many Westerners on glimpsing ceremonies designed to induce 'collective joy'. Captain Cook and Charles Darwin were both appalled at the *corroborree* rituals they saw in western Australia. 'It was a rude, most barbarous scene, and, to our ideas, without any sort of meaning,' the formulator of evolution wrote.

An English traveler to Trinidad witnessed a 'disgusting and fiendish saturnalia' break out amongst the black plantation workers one Christmas Eve. Traveler after traveler after traveler reproduces the same vocabulary to describe the scenes that they have seen: grotesque, primitive, bestial, frenzied, savagery, devil worship.[9]

Ehrenreich's survey of the thrill of dance, of ritual and the way it plugs the individual into a collective society is compelling. There are no sacred cows for her: high-volume rock music at an American high school football game is on a continuum that begins with spirit trances and ends with cheerleaders.

What both scenarios have in common is an emphasis on the collective. The cheerleading rite is as mean-

ingful, in its own context, as a dance to the sun, or as trance visits to one's ancestral spirits are in theirs. Belonging, however it is written and however it is resisted, is the key. The groups may be different and so too the gods, but the desire remains constant. However, as the next chapter will discuss, the notion of belonging – and allied to that, of permission – is never as simple as it might seem.

1 Bill Laswell, with Deyhim, issued his own interpretation of *Madman of God* in his *Shy Angels* (Cramworld, 2002) album. Deyhim's own willingness to explore a more popular, club-based music – witness Loop Guru's use of her voice on 'Sussan 11' (on *Duniya: The Intrinsic Passion of Mysterious Joy*, Nation Records, 1994) or the remixes by Doug Wimbish, Keith Le Blanc, Adrian Sherwood, Richard Horowitz and Skip McDonald on *Out of Faze* (Venus Rising, 2001). 2 Bowles' 1949 novel, *The Sheltering Sky* (Harper Perennial, 1998) was set in North Africa. 3 Coleman's album, *Dancing in your Head*, released in 1973 by A&M, was a direct product of his Moroccan epiphany: one track, 'Midnight Sunrise', is a recording of him playing sax alongside the master musicians in Jajouka during a religious ritual. 4 From an interview with Roberto Gatti, www.mybestlife.com/music/Sainkho.htm 5 The Greek word *temenos* refers to a precinct reserved for sacred purposes in temples, although it could also be applied to groves, etc, associated with gods. Nina Danino's film in part addresses itself to the sensory appreciation of the difference of such places. 6 From http://news.bbc.co.uk/2/hi/africa/7646108.stm 7 Linder [Sterling]'s *The Working Class Goes To Paradise* (2001) is a performance piece, several hours in length, that takes inspiration from the role of women (specifically the Shaker founder Mother Ann Lee) in ecstatic communion. The music in the work is usually delivered by several rock bands playing simultaneously and at high volumes. Linder's preparations for her performances start days before the public are admitted. On occasion, the performance is completed once the public are ushered out. 8 Umberto Eco, *Foucault's Pendulum* (Secker & Warburg, 1989). 9 Details and quotes from Barbara Ehrenreich, *Dancing in the Streets: A History of Collective Joy* (Granta Books, 2007).

6 Whose song is it anyway?

Music and movement... The myth of authenticity and the twin perils of appropriation and essentialism.... White Zulus and homohop.... Music of the world.

IN 'WALK THE DOG', a song that originally appeared in 1981 on the B-side of 'O Superman', probably the biggest-selling experimental single in history, Laurie Anderson took a playful tilt at Dolly Parton, the unchallenged queen of country music. Specifically, the Parton song that Anderson had in mind was 1973's 'My Tennessee Mountain Home', a work laden with sentimental schmaltz and, like the wonderful 'Jolene', one of the mainstays of Dolly's considerable repertoire. Now, it is hard to be mean about anyone who delivers lines like 'It takes a lot of money to look this cheap', and in any case, Dolly is a real phenomenon, a true-life, rags-to-riches, talent-conquers-all-story, but Anderson – who really isn't a mean person – had a point. What was Parton on about when she sang, '*In my Tennessee mountain home/ Life is as peaceful as a baby's sigh/ In my Tennessee mountain home/ Crickets sing in the fields nearby*'?

'Walk the Dog', delivered in Anderson's beguiling *Sprechstimme*, which was pitched-shifted upwards with the aid of a harmonizer device, responded to her memory of the song of Parton's memory of her Tennessee mountain home, thus: '*Well, you know she's not going to go back home/ And I know she's not going to go back home/ And she knows she is never going to go back there.*' And we do. In their own quiet, understated and un-histrionic way, Anderson's lines are utterly devastating. There is no return. There is no authentic experience.

Authentic myths

Yet that has not stopped people from looking for it. If anything, it has only spurred the search on with

a greater urgency. One of the most fraught areas of music criticism has (for a long time) been centered around the debate on authenticity, and this applies as much to world music as to any other. How black does a musician have to be to sing the blues? How ghetto tough to be a gangsta rapper? Is the theatrical exuberance of the New York-based, energetically multinational band Gogol Bordello sufficient to deliver klezmer music in the same way as Jewish or Romany musicians, from the Klezmatics, Balkan Beat Box, Max Pashm and John Zorn to the Taraf de Haïdouks, Boban Markovic or Fanfare Ciocarlia play it?

To cast Dolly Parton within this kind of reasoning, she is authentic as it is possible to be, given of course the caveats that attach to authenticity. She really did once have a Tennessee mountain home – it was a one-room cabin for her family in the Smoky Mountains. She really did grow up, in her words, 'dirt poor', enriched by a musical heritage that included the sounds of the country music in which her family were steeped, and of the Pentecostal church that they attended. If Parton needed to ask permission to sing what she sings about, it would be given without demur. She is what she is – and yet, when Parton exercises a right of return to her roots, they are inevitably transmogrified into kitsch – see, for example, the Dollywood theme park she and some backers created in 1986 on the site of a pre-existing tourist attraction. This is what Laurie Anderson latched on to: the impossibility of return.

Grimy aura

In reality, the entire notion of authenticity is a spurious one. If it was taken to its logical conclusion, musicians would exist only in fiefdoms of their own imaginings, unable to exercise any creative movement. The reinvigoration that comes to any artistic practice, via contact with the outside world – and with it, the

possibility of mutability or metaphorical counterpoint – would be unavailable.

The entire debate about authenticity began decades ago within classical music. It concerned period instruments, changes in tuning and transpositions to other instruments. But once the debate relocated to the arena of popular music, it changed its focus. Although to talk about authenticity within popular music is to talk about the roots of the sound and the closeness to those roots of its practitioners, what is rarely admitted is that the debate is about aura. The early blues historians mentioned before – Lomax, Handy and Scarborough – were obsessed with finding the source of black music. They each had their own political and cultural agendas to motivate their quests, but their focus was on the grail of an original music, as if that ever existed.

Aficionados of fado and rembetika have invented a grimy aura for their own music of choice, and similarly so with rebel music the world over – the good fight has to be clearly delineated and uncontaminated by contact with the enemy. The fact that Joe Strummer, for example, leader of the influential agit-punk band The Clash, came from a diplomatic family was something that was played down during his lifetime; similarly that Shane MacGowan, singer and chief writer to the Pogues, had won a scholarship to the same London public school attended by Baroque composer Henry Purcell some 300 years before him. With rock music's aura as a vehicle of 'authentic' working-class expression, it is not surprising that many of the highly successful middle class musicians within it choose to be vague about their backgrounds.

Whose right to sing or perform?

Given the highly subjective interplay between the aura of a work of art and its 'authenticity', where does the idea of permission fit in? Who has the right to sing a song? As we have seen, in some minority cultures, espe-

Whose song is it anyway?

cially those in which music has a clear ritual purpose, the performance of certain songs, dances and instruments is restricted to designated people within that group. To do otherwise is considered a most serious breach. This is a contentious area. To transgress in such a traditional arena may be to perform what seems like a simple action – for example, to play an instrument reserved for other people. In 2008, Harper Collins Australia strayed into problems when, shortly before publication, a section in *The Daring Book for Girls*, was found to have instructions on how to play the didgeridoo. Some Aboriginal leaders objected, saying that the instrument was reserved for men alone. Harper Collins quickly deleted the offending pages and replaced them with something less controversial.

Sensitivity is needed in cases such as this. Gender restriction may go against the grain of many people's thoughts, but it is nevertheless a warning against assuming that all cultures support universal rights for all – however much we may desire it. There are, in different scenarios, anxieties about the interplay between transgressive activities and appropriations, specifically when one political system seeks to undermine the cultural productions of another.

Tibet's heritage in exile

Tibet is a case in point. Since the independent state of Tibet was annexed by China in 1950, there has followed a systematic erosion of native religion and culture. Tibet's unique civilization has been subject to a far from benign process of Sinification. Accordingly, much of Tibet's cultural heritage is now preserved outside of its native land, in places such as the Indian town of Dharamsala, where the Dalai Lama has his base in exile and where the Tibetan Institute for the Performing Arts is located; or Tibet House in New York. For the occupying authorities, the expression of a Tibetan idiom by a Tibetan artist is provocative in

the same way as a Palestinian artist using Palestinian motifs is considered provocative in Israel.

The freedom to make music might be the principal reason why in 1989 the Tibetan singer Yungchen Lhamo fled to India from her home in Lhasa, escaping over the Himalayas. Yungchen's music has increasingly opened outwards towards international collaborations without losing its distinctive identity: to date, she has worked with Annie Lennox, Hector Zazou, Peter Gabriel's Real World team and players of the kora, steel guitar and North African percussion, as well as recording an album of devotional songs – *Tibetan Prayer* – with the monks of the Namgyal Monastery. By any standards, Yungchen is an elegant singer whose approach is rooted in her native culture. Western listeners to *Ama* (2006) might find that the album is, in terms of its soundworld, buffed to appeal to listeners more at home with Westernized scales than any Tibetan equivalents, but in no way does that invalidate Yungchen's responsibility towards her music.

Who else can use Tibetan music with impunity? Toby Marks, alias the Banco de Gaia, used tape loops of Tibetan chanting on 'Last Train to Lhasa', a 1995 club trance hit in Europe. Marks was motivated by his support for Tibetan independence as much as his concern for the effect that the Qinghai-Tibet railway – then a Chinese project not yet put into construction (it was opened in 2006) – would have on the territory. Banco de Gaia's track was well tailored to its audience, but it never pretended to be anything other than what it was. Faced with Sa Dingding, a young, telegenic Chinese virtuoso who grew up in Inner Mongolia and professes herself long fascinated by the regional music of China, by Tibetan culture and Buddhism, there are harder questions to answer.

Chinese crossover

Alive (Wrasse Records, 2008) is Sa Dingding's first album to be aimed at an international listenership. It

showcases her voice and instrumental abilities and it is captivating. With a judicious sprinkling of electro-beats and synthetic whooshes, *Alive* is clearly aimed at a crossover market. Sa Dingding sings in Mandarin, Sanskrit, Tibetan and languages of her own creation, including one called Lagu; she plays the *zheng*, the 25-string zither, and other instruments with a rare delicacy; her voice, either singing or chanting, has a presence that's deeply unusual. She has a proven interest in China's regional musics, having lived and studied in many different regions. She is also adept at incorporating digital sounds into her recordings. Visually, she works an image of dramatic glamor. It's not for nothing that Sa Dingding has been called the Chinese answer to Björk.

But whereas Björk, giving a concert in Shanghai in March 2008 – just months before a self-conscious Beijing hosted the Olympic Games – shouted 'Tibet! Tibet!' from the stage as she closed her song 'Declare Independence', Sa Dingding's stance on this seems non-committal.[1]

This is curious, considering the inclusion of Tibetan mantras on *Alive* and the fact that she appears on the album's cover in a dress adorned with an image of the Buddha. Is Sa Dingding simply a young musician, like Dadawa before her, who has strayed into territory more contentious than she realized? Dadawa, the stage name of Zhu Zheqin, is a Chinese musician who had a similar partiality for Tibetan music and motifs. Her use of some Tibetan samples on her 1995 album, *Sister Drum*, drew a certain amount of criticism when it was released outside China, given the fact that Tibetan culture is rigorously controlled by the Chinese occupation.

Sa Dingding is not, as some detractors might have it, an unwitting dupe for a colonial regime. It's possible that, in using her own made-up languages in her songs, she is trying to move beyond any kind of national chauvinisms regarding the positions of China vis-à-

vis Tibet. To recap Laurie Anderson's quip regarding Dolly Parton's song, the rewinding of historical events is impossible. From this distance, we cannot know. Sa Dingding is formed by Chinese culture and subject to Chinese restrictions. Without further information, it is more probable that, whatever the sympathetic treatment meted out here to Tibetan themes, *Alive* is, in at least some aspects, the product of a history of which it cannot stand truly apart.

Musical motives

To insist that a musician can only use the musical motifs of an oppressed culture if he or she identifies with the struggle of the oppressed is a blunt formulation – too blunt, it seems, for a world in which sampling – that is, dipping and rummaging around in sound sources from wherever – is a fact of life. Similarly, the tacit expectation – leveled from many sources – that musicians 'keep to their own' sounds is especially burdensome.

In an example of double-thinking that would have been hilarious had it not been so stupid, Living Colour – a US band with funk, punk and experimental edges – was often an object of curiosity because they were, wait for it, black men playing rock music. Growing out of the Black Rock Coalition's campaigns against the racial stereotyping of music, Living Colour's guitarist Vernon Reid nevertheless had to endure numerous questions at the hands of journalists about what it was like, being a black man in the white rock world.[2] 'We're black. We play rock and roll. Now maybe everybody will give that a rest,' said the band's vocalist Corey Glover.

But it hasn't been given a rest. Twenty-five years after the heyday of Living Colour, young artists, like the Afro-American musician and poet Kamanda Ndama (see box **Stereotyping**), are still complaining of a stereotyping that smacks of an essentialism. Funding bodies – councils who organize municipal shows, educators

Stereotyping

'My issue is race. I feel black people nowadays have to conform to this one ideal. We all have to be the same. We all have to be hard and ghetto and listen to only one genre of music which would be Rap and R&B. And if one of us steps out of the mould we're not black anymore. Well, that's dumb. When did music determine your racial background?' ■

Kamanda Ndama, Afro-American musician and poet.

and the like – would do well to take note. There is only a thin line between genuine cultural engagement and patronizing behavior. Once again, realness – in effect, a pastiche of a non-existent authenticity – rears its head.

There are some navigable routes through these territories which offer both parties a measure of genuine participation, but nevertheless the dilemma is a real one for anyone intelligent handling these options.

The white Zulu

When Johnny Clegg moved from Britain to Israel to Rhodesia (now Zimbabwe) and finally to South Africa, the boy (now seven) had little idea that he would end up being called 'le Zoulou blanc' – the white Zulu. Clegg, who had a jazz singer for a mother, had had contact with American and Afrojazz as a boy, but it was a chance encounter in Johannesburg with two Zulu musicians – Charlie Mzila in 1967 and the guitarist (and gardener) Sipho Mchunu two years later – that really fired his imagination. Clegg noticed that Mchunu's guitar was tuned in a completely different way to his own classical guitar – the adolescent Clegg had been returning from a guitar lesson when he encountered the older man.

Clegg learned the Zulu language, Zulu dances and music. He hung out with Zulus and formed a strong kinship. He and Mchunu founded Juluka ('Sweat') in 1969, one of South Africa's first mixed-race bands, and quickly built up a following. Their participation wasn't exactly illegal in apartheid South Africa, but it

was sufficiently seditious for Juluka to be monitored by the police. Delivering a Zulu rock sound, pounding with such popular rhythms as *maskanda* and *mqbaqanda*, Juluka were a savvy entity, and their albums *Universal Men* (Rhythm Safari, 1978) and *African Litany* (Rhythm Safari, 1981) did not shy away from a political agenda which included trade union rights and the end of the apartheid system.

When Juluka disbanded in the mid-1980s, Clegg formed a new band, Savuka ('We Have Arisen'), which ramped up the political content. Songs such as 1987's 'Asimbonanga' ('We Have Not Seen Him') – on *Third World Child* (EMI) – which demanded the liberation of ANC leader Nelson Mandela and chanted the names of Steve Biko and other South African freedom fighters; plus the best-selling follow-up *Shadow Man* (EMI, 1987), coupled with a relentless touring schedule, put Clegg firmly on the international map.

Back in the USA

Of course, sometimes such is the imperative towards authenticity that there can be no better way to perform it than to subvert its commands. One of the best examples of this technique was the collective of 'seven queer Negroes' (their term) from Oakland, California, who made up the Deepdickollective (D/DC). Formed in 2000 and disbanded in 2008, the D/DC's debut album *BourgieBohoPostPomoAfroHomo* (Sugartruck Recordings, 2001) has the beats and the smarts to tune ears and turn heads. It is a rap album that combines the polemical capacity of Public Enemy with the poetic flow of Gil Scott Heron and it is the rap that dares to speak its name: homohop.

D/DC

As with the burgeoning 'homothug' trend (that is, blacks and Latinos who dress like gangsta rappers and eschew 'gay' idioms), the D/DC inhabited a world

that has read its Judith Butler and watched *Paris Is Burning* (1990). It knows about gender performance and it knows about the phenomenon of 'passing' oneself off as the real thing (and the inversion of it) that Jennie Livingston's documentary about New York's vogueing balls explored.[3]

The theorists of the D/DC know that all the world's a stage and that performance is a multifarious thing. As the title to *BourgieBoho* suggests, Tim'm West (aka 25 percenter), Juba Kalamka (aka Pointfivefag), Phillip Atiba Goff (the Lightskindid Philosopher) and their D/DC colleagues also know the difference between Barthes and Blunts, and it shows. They take a highly literate route through Afrocentrism, homophobia, racism – all to the sounds of a drum 'n' bass minimalism and loops of violins, thrown out with the poise of performance poets. Titles like 'Grammatology' and 'Oxymoronicon' showed just how very unlike Eminem the D/DC were.

During its lifetime, the D/DC was a clever, informed counterblast to the homophobic onslaughts that characterize so much of rap's braggadocio. The D/DC even wondered if stars such as Eminem and Public Enemy protested a little too much. Equally importantly, it set an agenda, musically and politically. Today, gay rappers are not an isolated phenomenon. In the US, Phat Family is a record label dedicated to homohop, and the number of individual artists and crews is encouraging: from Florida, Shunda K and Jwl B's duo, Yo! Majesty; from California, Deadlee; Cazwell from the East Coast and Katastrophe, Hanifah Wallida, Doug E and Marcus Rene Van West Coast – and this is but a minuscule selection. It is hard to imagine Alex Hinton's documentary film on gay hip-hop, *Pick Up the Mic* (2006) without the pioneering work that the D/DC did.

Close to parody
Because to speak of authenticity within art is in effect to speak of a fantasy, it means that parody is just a

breath away. Exoticism is essentially a product of such fantasy – the négritude of Josephine Baker dancing her *Danse sauvage* in a skirt of bananas and little else in the cabarets of Paris in the 1920s; Yma Sumac, nicknamed 'the Inca princess' (she wasn't) with the feathers in her hair, and of course Brazilian-raised Carmen Miranda, with the fruit bowl hat on her head.

Om Kalsoum and Fairuz, both towering figures in the history of popular Arabic song who certainly didn't resort to such eye-catching costumes, are sometimes dragged into the realm of the exotic, while Martin Denny – one of the few men in the pantheon of the exotic – was virtually synonymous with it. The feminization of the exotic is a well-rehearsed topic: Denny, unlike Baker, Sumac et al, was not a performer in the same way. Denny was an American bandmaster and composer who fed a 1950s craze for all Polynesian Tiki culture with a lounge orchestra given to making parrot calls and frog croakings over their music.

Critic David Toop writes in *Exotica*[4] that The Pacific Rim was 'a tabula rasa for fantasy, both sincere and ironic'. Denny, various other musicians too, were happy to raid the toolbox of Asian, Cuban and otherwise unusual instrumentation for their own ends – Toop lists some that appeared on album covers from Denny and his sometime vibraphonist Arthur Lyman: 'tuned Burmese gongs, Chinese gong, Tahitian woodblock, Hawaiian gourd, piccolo, xylophone, boobams, a new invention called the magnaharp and non-percussion such as the Indian sitar and Japanese koto and shamisen.'

Tenement Museum sounds

This array of new sounds might have added color to the standard musical spectrum on offer at the time, but it did little to promote new music or illuminate its systems. But that was never its intention. The exotic, like the authentic, exists only in the realm of the

unreal. But where then does the imaginary exist?

In 2006, the Tenement Museum in New York invited two musicians, the Angolan-Portuguese composer Victor Gama and the Briton David Gunn, to create a work that addressed the experiences of contemporary immigrants in the city. The Lower East Side, where the museum is situated in an apartment building dating from 1863, is a place that has long encapsulated America's immigrant experience. In the 19th and early 20th centuries, the area thronged with new arrivals – Russians, Italians, Greeks, Germans, citizens from the Austro-Hungarian Empire, Irish, Eastern European Jews and many other nationalities and ethnic groups. They were all united in a common struggle: to get themselves established in the New World.

Gunn, who was also the museum's digital artist in residence, and Gama came up with *Folk Songs for the Five Points*, a project that is still in operation via the museum's website. The Five Points (the historic focal point for Martin Scorsese's film *Gangs of New York*) no longer exist. Instead, this area in lower Manhattan has become known by other names: Loisaida, Chinatown, Kleindeutschland, Little Italy, the Lower East Side. But it is this history, one of a city shaped by immigrant memory and musical culture, that Gama and Gunn raise, to create their music. Folk songs for both these experimental artists are truly the malleable material of the people.

Musical approaches

With Gama, whose approach to music has led him to create his own instruments to contextualize sound as part of an interactive universe, the duo recorded sounds (steam escaping from manholes, a squeaky 2nd Avenue train, a seafood salesman, neighborhood music and one man, fresh out of prison, speaking of his hope for his future) and coupled these with fragments of instrumentals from Gama himself. Strummings

from Gama's toha or totem harp (something like a kora, only with more strings) and hissing steam, turned into percussion give way to human voices, the rhythm of motors and speech. It is a gentle, thoughtful music that draws a subtle attention to the environment and to contemporary immigration. Just as the origin of New York's immigrants has changed over time, change is at the heart of this, where by turning into something else, one is taking part in a continual process of becoming.[5]

Even though the *Folk Songs* project draws from the historical contexts of the cities it addresses (the artists have also extended to other locations), it is the very antithesis of memorializing. Music has often been created with posterity in mind (one thinks of praise singers in all cultures, and not necessarily those served by hereditary griots), and it has been wrought sometimes in the most terrible of conditions. Incarcerated in the ghettos of Warsaw and Bialystok, and Theresienstadt concentration camp, Jews conducted what historian Shirli Gilbert has described as 'spiritual resistance' and 'eleventh-hour ethnography'. Songs were written, questionnaires, interviews and folkloric data collected and secreted in various receptacles. At Theresienstadt, Victor Ullman composed numerous works, including *The Emperor of Atlantis, or the Refusal of Death*. Two milk cans containing fragments of Emanuel Ringelblum's archive, *Oyneg Shabes* ('Joy of the Sabbath') were, after the destruction of the Warsaw Ghetto, found buried in its ground.[6]

Victor Gama

The work of Victor Gama, in particular, illustrates the never-ending continuum upon which traditional music exists. Born and raised in Angola, one of his earliest musical memories was of watching an old man playing an *ungu* – 'the ancient bow that gave origin to

the *berimbau* in Brazil' – on the beaches of Luanda. 'The repeated hitting of the stick on a single string, suddenly stopped and then released by one finger, along with the effect produced by the mouth of the gourd touching the belly of the musician, produced a magical and hypnotizing soundscape,' Gama says. But this memory was also the beginning of a realization that music was something that is charged with meanings that go far beyond the organization of notes on a stave. Music is greater than that: it is a multi-dimensional system that can at any point require new instruments to express new sounds, the blessings of ancestors or the return to ancient systems of knowl-edge. Gama's *Odantalan* (2002) was nothing less than a complete cultural package – a book, recording, and the graphic writing systems of the old Kongo/Angola civilization. It was, effectively, an acknowledgement of a complex network in which humankind and its creations – social and cultural, material and spiritual are bound together and projected outwards. And as such, it is the very ethos of world music.

In 2006, Gama returned to Angola to begin work on *Tsikaya*. Named after a traditional Angolan instru-ment, the *Tsikaya* project began with an initial inter-est in the forms of music that were being produced in the remote province of Cuando-Cubango after years of conflict. Gama, whose own organization PangeiArt is working with Angolan NGOs with some financial support from the Netherlands Institute for Southern Africa, had the idea to reinforce traditional music by creating a database containing music, film and other information about musicians and their productions.

Musicians have, interestingly, already used the recording facilities offered as a way of sending messages out to the world. It was given a greater urgency by the knowledge of how friable this music must be. *Tsikaya* is not designed to be an archival project, but a living entity – something that Angolan

musicians and new composers can use to refashion the world. Music making and world building: it comes down to the same thing. And to have regard for both should, in an ideal world, translate into a concern for the person who makes the music, as we see next. But this is a far from an ideal world.

1 Björk has good form when it comes to asides from the stage. When English fans of the Reykjavik-based Sugarcubes shouted 'Speak English!', Björk replied, 'Learn Icelandic!' 2 That question is a variant of the 'women in rock' one. Founded in 1985 by Vernon Reid, producer Konda Mason and *Village Voice* writer Greg Tate, the Black Rock Coalition continues as a not-for-profit organization 'dedicated to the complete creative freedom of black artists'. See www.blackrockcoalition.org. 3 Growing up in the underground gay black and Latino clubs of the US in the 1980s, vogueing is a dance style that combines freeze-frame movements inspired by the fashion catwalks with athletic balance and poise. Jennie Livingston was pipped at the post in getting vogueing out to wider recognition by singles from Malcolm McLaren ('Deep in Vogue', 1989) and Madonna ('Vogue', 1990), but her documentary, several years in the making, provides an extraordinary testimonial to the self-invention and resilience of the community she films. 4 *Exotica* (Serpent's Tail, 1999). 5 Visitors to the Tenement Museum's website can manipulate the raw material of Gama and Gunn's sound map to create their own folk songs: http://tenement.org/folksongs/. Gama and Gunn have also extended the idea of creating new folk songs to Portugal (*Cinco Cidades*) and Manchester (*Manchester: Peripheral*). See www.folksongsproject.com. 6 See Shirli Gilbert, 'Buried Monuments: Yiddish Songs and Holocaust Memory', *History Workshop Journal*, Autumn 2008, issue 66.

7 Lift up your voice

'Were you a witness?'
Diamanda Galás, *Plague Mass* (Mute, 2000).

World music, ubiquitous sounds and lost communities... The power of song and the fear of silence.

WHY WORLD MUSIC and why now? Is one subconscious element of the current popularity of world music a desire to find a community, a place to unburden oneself and relax, a place where one might work in concert? Is world music something that, in the words of the slogan of the Putumayo record label, something 'guaranteed to make you feel good'?[1] However you choose to deal with these questions, the many speculative answers must take on much more than the contemporary availability to access such music in stores or in the media.

Even up to a short 60 years ago, music was a much more communal resource. People played instruments, went to films and concerts, social gatherings and religious services. They gathered around the radio or television to hear music performed in real time. There was no opportunity for personal playback as we have now. Music, among all the other things it can be, was a social resource. For years, the Friday morning playgrounds of British schools were full of teenagers eagerly chatting about the bands they had seen the evening before on *Top of the Pops*, the BBC TV's flagship popular music program.

When an extraordinary performance occurred – for many of the pre-punk generation, myself included, it was seeing David Bowie perform 'Starman' in 1972 – it was an electrifying event and it was something that we could share. Personal players, beyond the portable transistor radio, a relic of the 1960s, did not exist. Personal cassette players – exemplified by the Sony Walkman in the 1980s – then CD players and, in the

first decade of the 21st century, the MP3 player, epito-
mized by the success of the sleek iPod – had yet to be
invented. And with the wonder of digital technology
have come individual playlists, personalized listening,
worlds of sound made just for one.

Music's effects

One powerful idea is that music's efficacy has to do
with the emotional and physical immediacy afforded
by human engagement. However one participates with
music, likely or not, there will be a bodily aspect: we
dance, we tap our fingers, we sing or hum along. Of
all these, it is possibly the action and effect of singing
that is most charged. Singing is an activity that
employs not just the vocal cords, but also the body's
resonating spaces; singing requires an attention to
breath control. Too much oxygen coming in can make
you hyperventilated and feeling faint; too little air and
your voice diminishes into a croak. Ask any singer
about the impact of singing really well, and they will
speak of being on top of things, their body and mind
working in a particular kind of harmony, rather like
a runner who, operating at a premium level, speaks of
being 'in the zone'.

Amongst the rich variety of musicians, it is the
singers who are the athletes. Listeners, never the
passive vessels that some might have them, can recog-
nize this. It is not for nothing that the idiom, 'to find
one's voice' has a long history of usage, and that world
music has to do with – to borrow a word from the
ethnomusicologist of American folk song, John Lomax
– the 'uncontaminated' voice. The notion of the voice
unalloyed by the pollutants of modern society and the
enchantment that such a voice produces is the subject
of the historian Marybeth Hamilton's *In Search of the
Blues*, a book not so much about the history of the
'discovery' by white listeners of black music, but what
she describes as an 'unimagined transcendence a level

of emotional intensity otherwise out of their reach... a vicarious ecstasy' that these collectors sought.

Messages

The fact that often the songs of world music are delivered in languages (and may carry messages on the social position of women, gays and lesbians and other groups that are hardly congenial to a liberal democracy) that few outsiders understand is immaterial. What is important is that the music and the song can transport its listeners somewhere else, to a place where on an emotional level the strict lines of demarcation between people soften and blur.

If this ecstasy is a kind of reaching beyond oneself, is it a consequence of the group activity that so interested Sigmund Freud in his formulations of mass psychology? Written as early as 1921, his *Group Psychology and the Analysis of the Ego* considered the behavior of the individual when subsumed into a group. Freud chose the church and the army as two examples, but he could quite easily have chosen crowds at a concert, dancers at a club or fans at a football match.

The attraction of joining the group, to effectively relinquish the burden of individuality (with all its attendant prohibitions) to merge with others, is a seductive one. Crowds are emotive entities: adults cry and embrace at football matches; in Pentecostal-style church services, members of the congregation may fall to the floor, their language unloosed by the outpourings of a glossolalia or 'speaking in tongues'.

Being part of a crowd also emphasizes a sense of community: a reason why, in situations where communities need to be forged, song is so important. For example, after the foundation of the state of Israel in 1948, public singsongs were as much a part of building a sense of nationhood as they were a tool for teaching the new country's multilingual population the state language of Hebrew. And crowds are

also highly sentimental: consider the jingoist ritual of the Last Night of the Proms at the Royal Albert Hall in London, where the chorus of 'Rule Britannia' is always a tour de force of flag-waving. Crowds also rouse easily, which is why the military has placed such a high premium on its music, not just for ceremonial purposes that accentuate a pomp and circumstance, but preparing its combatants – and rallying them – for warfare.

Moved by music

In recent years, the human proclivity to be so moved by music has also been a subject explored by artists whose practice does not usually fit into the rubric of music. *Turbulent* (1998), a piece of video art by two Iranian-born artists, filmmaker Shiran Neshat with composer/performer Sussan Deyhim, which used split screens facing each other at either end of a gallery to make a point about gender separation in Islamic, and specially revolutionary Iranian, society. *Turbulent* is a counterpoint of two songs, one on each screen, filmed in the same auditorium, and playing simultaneously. On one screen, actor Shoja Youssefi Azari (voiced by the popular singer Sharam Nazeri) sings romantic songs in Farsi before his appreciative all-male audience. They clap, smile, nudge their friends – this is a social occasion, all guys together. At the other end of the gallery stands the statuesque, black-robed Deyhim. She is utterly alone. No audience, just her and her wordless, terrifying, sensual, song – a series of visceral growlings that give way to ululating arpeggios. She seems to summon up some ancient power as she does so. It is an incandescent noise. It burns the ears. Is it an incantation or a love song? Neither Neshat or Deyhim tell us, and that refusal informs much of the film's power.[2]

For *Clamor* (2006), a Latin word that means both cry and shout, Jennifer Allora and Guillermo

Lift up your voice

Calzadilla created a life-size pillbox (that is, a Second World War fortification of a type still to be found around the British coastline) into which they stuck a brass band that belted out blasts of martial music, in such a way that it sounded as if a titanic sonic struggle was taking place in the box itself.

When the new British national stadium opened at Wembley in 2007, the US artist Paul Pfeiffer took the opportunity to create a massive sound installation. Situated in an empty building next to the iconic ground, *The Saints* (2007) gave forth a sweep of surging crowd noises: national anthems, collective joy and despair, the rhythmic chanting of the names of England's 1966 World Cup-winning footballers. Allora and Calzadilla's ultimate theme is state power and aggression, while Pfeiffer's is one of precarious national identity, and yet all three artists are concerned with the power of music, how it motivates and what it mobilizes.

Susan Hiller, on the other hand, concentrates on something as fundamental as language. Her film work *The Last Silent Movie* (2007) is a composition made from human voices speaking extinct or dying languages – Blackfoot, K'ora, Southern Sami and 21 other examples. Hiller's sources were either ethnographic sound archives or native speakers. In her work, some voices sing, others recite lists of words and others tell stories. Each language has its own rhythm, its own modulation. Patterned together, she makes a counterpoint as harmonic as it is human. For Hiller, listening is a way of underscoring the breath of life. Silence here does mean death.

Singing together
Community singing, as Pfeiffer and so many before him know, is hugely powerful. It affirms you in your group membership, it joins you to your fellows – and, it is something rarely indulged in today, except in the

secular churches of sports stadia and concerts. This lack of any opportunity to join in song is a characteristic of our contemporary society and it a reason why, in missing the occasions afforded by church, rallies and other assemblies, we make them. From dance chants to karaoke parties to football anthems to singalong screenings of popular musicals such as *The Rocky Horror Show* and *The Sound of Music*, the yearning for the benefits brought by an involvement with music, and specifically the voice, is a fundamentally human quest.

Joe Boyd, the US-born record producer whose activities put him at the heart of the explosion of rock and folk music in the 1960s, has suggested that 'the rise in world music in the 1980s was triggered in part by the disillusion with pop and a search for the kind of energy we once found in Miles Davis, Jimi Hendrix, Otis Redding, Bob Dylan or even the [Rolling] Stones'.[3] Boyd adds that a 'quest for authenticity leads audiences to experience "local culture" at events in the Sahara desert, Zanzibar, Essaouira, the Spanish and Colombian Cartagenas, Rajasthan, Siberia, Hungary, Salento, Jamaica and Brazil'.

There is much in what Boyd writes. But is part of the attraction of world music something more? And is there within it the desire to form communities, to unburden ourselves, to dissolve the boundaries that describe each individual ego, in order to work – and here's a loaded metaphor – in concert? Just a question.

World music does, like anything else, have its fads. As I write this, two of the hottest ones are for Tuareg proto-blues, typified by the band Tinariwan, and for Gypsy music of bands and artists such as the Taraf de Haïdouks. Of the latter category, I've lost track of the number of CDs that have arrived on my desk over the past year proclaiming themselves to be the latest highpoint of Gypsy musical culture. Perhaps they are. Many are joyous, vibrant affairs.

The same is true of Jasmine Dellal's *Where the Road Bends: Gypsy Caravan* (2006), a documentary on Gypsy music that has been enthusiastically endorsed and publicized by actor Johnny Depp, and Garth Cartwright's account of his journeys amongst the Gypsies, *Princes amongst Men* (2005). And yet the production of these albums, films and books is simultaneous with appalling (and historically continuous) privation and abuse. Writing in *The Guardian* in July 2008, Seumas Milne reported that:

> 'Last week, Silvio Berlusconi's new rightwing Italian administration announced plans to carry out a national registration of all the country's estimated 150,000 Gypsies – Roma and Sinti people – whether Italian-born or immigrants. Interior minister and leading light of the xenophobic Northern League, Roberto Maroni, insisted that taking fingerprints of all Roma, including children, was needed to "prevent begging" and, if necessary, remove the children from their parents.'[4]

It is unlikely that either Berlusconi or Maroni will be sighted any time soon grooving on down to a set given by the Taraf de Haïdouks or any of their younger co-musicians. But that is not quite the point. The point is simply this: why bother going to the trouble of cultivating an abstract, aesthetic or even ecstatic enthusiasm for 'other' musics, if this does not translate into the care of the bodies who make the sounds so sought after? Both world music and the world of music have no separation from the humanity that makes it. To try to sunder them would be a specious activity.

When, in 1987, that diverse group of people met at the Empress of Russia to figure out a way to get what they were to call world music out into the wider

world, it was not to supply sound as a commodity but, perhaps, to extend the idea of what humanity and its creations actually are.

1 'Q&A: Dan Storper, Founder of Putumayo World Music', *The Ampersand*, 11 August 2008, http://network.nationalpost.com/np/blogs/theampersand/archive/2008/08/11/q-amp-a-dan-storper-founder-of-putumayo-world-music.aspx. 2 Louise Gray, 'Ways of Hearing', *Visionary Landscapes: The Films of Nina Danino* (Black Dog, 2005). 3 Joe Boyd, 'Plink, plink Fez', *The Guardian*, 28 June 2008. 4 Seumas Milne, 'This persecution of Gypsies is now the shame of Europe', *The Guardian*, 10 July 2008.

Resources
Discography, bibliography and websites

Sound

Justin Adams, *Desert Road* (World Village, 2002).

Justin Adams & Juldeh Camara Trio, *Soul Science* (Wayward, 2007).

Amadou and Mariam, *Dimanche à Bamako* (Because Music, 2005).

Rim Banna, *The Mirrors of My Soul* (KKV/Valley Entertainment, 2006).

Afel Bocoum, Damon Albarn, Toumani Diabaté and Friends, *Mali Music* (Honest Jon's Records, 2002).

Cristina Branco, *Murmúrios* (L'Empreinte Digitale, 2007).

Brigada Victor Jara, *15 Years of Traditional Portuguese Music* (Playasound, 1993).

David Byrne and Brian Eno, *My Life in the Bush of Ghosts* (Virgin/EMI, 1981).

Nick Cave and the Bad Seeds, *The Good Son* (Mute, 1990).

Johnny Clegg and Savuka, *Third World Child* (EMI, 1987).

Mano Chao, *Clandestino* (Virgin, 2000).

Mano Chao, *Proxima Estacion Esperanza* (Virgin, 2001).

Ornette Coleman, *Dancing in your Head* (A&M, 1973).

Sussan Deyhim, *Madman of God: Divine Love* (Cramworld, 2000).

Sussan Deyhim and Shirin Neshat, *Turbulent* (Eyestorm, 1998).

Toumani Diabaté, *Kaira* (Hannibal, 1988).

Toumani Diabaté, *The Mandé Variations* (World Circuit, 2008).

Toumani Diabaté and the Symmetric Orchestra, *Boulevard de l'Independence* (World Circuit, 2006).

Etran Finatawa, *Desert Crossroads* (Riverboat, 2008).

Lajkó Félix, *Felix* (via www.passiondiscs.co.uk, 2002).

Diamanda Galás, *Defixiones, Will and Testament, Orders from the Dead* (Mute, 2003).

Victor Gama, *Odantalan* (PangeiArt 2002).

Victor Gama, *Pangeia Instrumentos* (Rephlex, 2003).

Gnawa Night, *Music of the Marrakesh Spirit* (Axiom/Island, 1991).

David Gunn and Victor Gama, *Folk Songs for the Five Points* (Lower East Side Tenement Museum, 2006).

Emmanuel Jal and Abdel Gadir Salim, *Ceasefire* (Riverboat/World Music Network 2005).

The Handsome Family, *Singing Bones* (Loose, 2003).

Mickey Hart, *Planet Drum* (Rykodisc, 1991).

Huun-Huun-Tu, *Sixty Horses in My Herd* (Shanachie, 1999).

Huun-Huun-Tu (with Sainkho), *Mother-Earth! Father-Sky!* (Jaro, 2008).

Reem Kelani, *Sprinting Gazelle* (Fuse, 2006).

Nusrat Fateh Ali Khan, *The Last Prophet* (Real World, 1994).

Nusrat Fateh Ali Khan, *Anthology* (Navras, 2008, 4CDs).

Konono No. 1, *Congotronics* (Crammed Discs, 2005).

Bassekou Kouyate and Ngoni ba, *Segu Blue* (Out/Here, 2007).

Kronos Quartet, *Kronos Caravan* (Nonesuch, 2000).

Laibach, *Volk* (Mute, 2006).

Yungchen Lhamo, *Ama* (Real World, 2006).

Yungchen Lhamo, *Tibet Tibet* (Real World, 1996).

Alan Lomax Collection, *Blues Songbook* (Rounder, 2003).

Madredeus, *Electronico* (Virgin, 2002).

The Master Musicians of Jajouka, *Brian Jones Presents the Pipes of Pan at Jajouka* (Polygram, 1996).

The Master Musicians of Jajouka featuring Bachir Attar, *Apocalypse across the Sky* (Axiom/Island, 1992).

The Master Musicians of Joujouka, *Joujouka Black Eyes* (Sub Rosa, 1995).

Mariza, *Boxed Set* (EMI Portugal, 2007).

Mariza, *Terra* (EMI Portugal, 2008).

Daniel Melingo, *Maldito Tango* (Manana, 2008).

MIA, *Arular* (XL Recordings, 2005).

Jelly Roll Morton, *Complete Library of Congress Recordings* (Rounder, 2005, 8CDs).

Muzsikás, *Blues for Transylvania* (Hannibal/Rykodisc, 1990).

Muzsikás, *Máramaros: The Lost Jewish Music of Transylvania* (Hannibal/Rykodisc, 1993).

Najma, *Atish* (Triple Earth, 1989).

Les Negresses Vertes, *Mlah* (EMI/Virgin France, 1992).

Rizwan-Muazzam Qawwali, *Sacrifice to Love* (Real World, 1999).

Amália Rodrigues, *The Best of Amália Rodrigues* (EMI France, 1999).

Sainkho (Namchylak), *Naked Spirit* (Amiata, 1999).

Sainkho (Namchylak), *Stepmother City* (Ponderosa, 2000).
Márta Sebestyén, *Márta Sebestyén and Muzsikás* (Hannibal/Rykodisc, 1987).
Harry Smith (ed), *Anthology of American Folk Music* (Smithsonian Folkways Recordings, 1952/1997, 6 CDs).
Taraf de Haïdouks, *Honourable Brigands, Magic Horses and Evil Eye* (Crammed Discs, 1995).
Taraf de Haïdouks, *Maskarada* (Crammed Discs, 2007).
Tinariwen, *Aman Iman* (Independiente, 2007).
Toumast, *Ishumar* (EMI/Real World, 2007).
Ali Farka Touré, *Savane* (World Circuit, 2006).
Ali Farka Touré and Toumani Diabaté, *In the Heart of the Moon* (World Circuit, 2005).
Rokia Traoré, *Tchamantché* (Nonesuch, 2008).
Various Artists, *Buena Vista Social Club* (World Circuit Records, 1999).
Various Artists, *The Festival in the Desert* (Independent/Wayward, 2003).
Various Artists, *Fonotone Records, Frederick, Maryland* (Dust to Digital, 2005).
Various Artists, *Fünf Griechen in der*

Hölle *und andere Rembetika Lieder* [*Five Greeks in Hell and other Rembetika Songs*] (Trikont, 1983).
Various Artists, *Lullabies from the Axis of Evil* (KKV/Valley Entertainment, 2004).
Various Artists, *Mourmourika: Songs of the Greek Underworld 1930-1955* (Rounder, 1999).
Various Artists, *My Only Consolation: Classic Pieiotic Rembetica 1932-1940* (Rounder, 1999).
Various Artists, *The Rough Guide to African Blues* (World Music Network, 2007).
Various Artists, *The Rough Guide to Fado* (World Music Network, 2004).
Various Artists, *Rembetika:* Songs *of the Greek Underground 1925-1947: Manges, Passion, Drugs, Jail, Disease, Death* (Klang Records, 2003).
Various Artists, *The Rough Guide to Rebétika* (World Music Network, 2004).
Various Artists, *Women of Rembetika* (Rounder, 2000).
Les Yeux Noirs, *tChorba* (Recall/Sony, 2005).
West-Eastern Divan Orchestra/Daniel Barenboim, *West-Eastern Divan Orchestra/Daniel Barenboim* (Warner Classics, 2006).

Words

Simon Broughton, Mark Ellingham, Richard Trillo (eds), *The Rough Guide to World Music, Vols 1 & 2* (Rough Guides, 2006 & 2000).
Judith Butler, *Precarious Life: The Powers of Mourning and Violence* (Verso, 2004).
Garth Cartwright, *Princes amongst Men: Journeys with Gypsy Musicians* (Serpent's Tail, 2005).
Jean-Pierre Chretién with Jean-Paul Dupaquier, Marcel Kabanda, Joseph Ngarambe and reporters sans frontières, *Rwanda: Les médias du génocide* (Editions Karthala, 1995).
Matthew Collin, *Guerilla Radio: Rock 'n' Roll Radio and Serbia's Underground Resistance* (Serpent's Tail, 2002).
Kimberley DaCosta-Holton, *Performing Folklore: Ranchos Folclóricos from Lisbon to Newark* (Indiana University Press, 2005).
Barbara Ehrenreich, *Dancing in the Streets: A History of Collective Joy* (Granta, 2007).
Kudsi Erguner, *Journeys of a Sufi Musician* (Saqi, 2005).

Philip Gourovitoh, *Wo Wich To Inform You that Tomorrow We Will Be Killed with Our Families* (Picador, 1995).
Marybeth Hamilton, *In Search of the Blues: Black Visions, White Voices* (Jonathan Cape, 2007).
Will Hodgkinson, *Guitar Man* (Bloomsbury, 2006).
Gail Holst, *Road to Rembetika: Music of a Greek Sub-Culture – Songs of Love, Sorrow and Hashish* (Denise Harvey & Co, 1974, fourth ed. 2006).
Alan Lomax, *Folk Song Style and Culture* (Transaction, 1994).
Alan Lomax, *The Land Where Blues Began* (New Press, 2002).
Alan Lomax, *Selected Writings, 1934-1997* (Routledge, 2005).
Alexei Monroe, *Interrogation Machine: Laibach and NSK* (MIT, 2005).
Robert Palmer, *Deep Blues* (Penguin, 1981).
Elias Petropoulos, *Songs of the Greek Underground: The Rebetika Tradition* (Saqi, 2000).
Guthrie P Ramsey, Jr, *Race Music: Black Cultures from Bebop to Hip-Hop* (University of California Press, 2003).

Allan Thompson (ed), *The Media and the Rwanda Genocide* (Pluto, 2007).

David Toop, *Exotica: Fabricated Soundscapes in the Real World* (Serpent's Tail, 1999).

David Toop, *Ocean of Sound: Aether Talk, Ambient Sound and Imaginary Worlds* (Serpent's Tail, 2001).

David Toop, *Haunted Weather: Music, Silence and Memory* (Serpent's Tail, 2005).

Caetano Veloso, *Tropical Truth: A Tale of Music and Revolution in Brazil* (Bloomsbury, 2003).

Paul Vernon, *A History of the Portuguese Fado* (Ashgate, 1998).

Films and DVDs

Buena Vista Social Club (Wim Wenders, World Circuit, 1999).
Channels of Rage (Anat Halachmi, Anat Halachmi Productions, 2003).
Martin Scorsese Presents the Blues (Sony DVD, 2003).
Musical Brotherhoods from the Trans-Saharan Highway (Hisham Mayet, Sublime Frequencies, 2008).
Searching for the Wrong-Eyed Jesus (Andrew Douglas, Plexi Film, 2006).
Slingshot Hip Hop (Jackie Reem Salloum, 2008).
Sufi Soul: The Mystic Music of Islam (Simon Broughton, Riverboat Records/World Music Network, 2008).
Where the Road Bends: Gypsy Caravan (Jasmine Delall, 2006).

Festivals, fairs and websites

Some of the many sites currently reviewing and promoting world music. A number offer free MP3 downloads, access to radio stations and podcasts. Kadmus Arts (http://kadmusarts.com) offers a very useful 'find a festival' world search on its website.

Matt Barrett's Travel Guides – Rembetika and Greek popular music: www.greecetravel.com/music/rembetika/

Black Rock Coalition
www.blackrockcoalition.org

Corner Prophets
Jerusalem-based hiphop dialogue with Sagol 59 and more. http://cornerprophets.com

c.sides Festival for Independent Electronic Music and New Media Arts
Ronni Shendar and Till Rohmann form an Israeli-German curatorial team that enganges with Palestinian, Israeli and other artists and human rights organizations to promote dialogue and peace. www.csides.net

El-Funoun Palestinian Popular Dance Troupe
Over 50 dancers and musicians who, in the words of one of its founders, Omar Barghouti, both challenge traditions and preserve them. www.el-funoun.org

Fat Planet: www.fatplanet.com.au/blog/

Festival Gnaoua et Musiques du Monde d'Essaouira
www.festival-gnaoua.net
This Moroccan festival dedicated to all things Gnaoua has been going for over ten years, and despite spreading its wings to bring in international artists, it nevertheless manages to remain true to its Gnaoua heritage and mystical traditions.

Festival in the Desert: www.festival-au-desert.org
Going since its foundation 2001 by Tinariwen, Lo' Jo, Issa Dicko and EFES, a local Tamashek organization, this festival, held in Essakane, Mali, celebrates Toureg music and its fellow travelers in great style.

Festival on the Niger/Festival sur le Niger
www.festivalsegou.org

Festival of World Cultures
www.festivalofworldcultures.com

Folksongs for the Five Points: www.folksongsproject.com

Freedom of Musical Expression
www.freemuse.org

Victor Gama: www.victorgama.org

Charlie Gillett's Sound of the World: www.soundoftheworld.com
Mondomix: mondomix.net
Museu do Fado (Museum of Fado):
www.museudofado.egeac.pt
Music Village festival
www.culturalco-operation.org
National Geographic: http://worldmusic.nationalgeographic.com/worldmusic/view/
page.basic/home
Rock Paper Scissors
www.rockpaperscissors.biz
Sautari za Busara
Zanzibar festival. www.busaramusic.org
Smithsonian Folkways Recordings: www.folkways.si.edu/index.html
Traditional Crossroads
Harold Hagopian's quality record label dedicated to all things Middle Eastern – and
then some. www.traditionalcrossroads.com
WOMAD: http://womad.org/
WOMEX: www.womex.com – Held every October, the biggest conference, showcase
and trade fair for world music in the world.
World Music Central: http://worldmusiccentral.org/
World Music Network: www.worldmusic.net/wmn/

Magazines
fRoots
www.frootsmag.com
Songlines
www.songlines.co.uk
The Wire
www.thewire.co.uk
Radio and podcasts
The URLS of international radio stations preloaded in iTunes have some great
offerings, from Iranian pop (Radio Darvish) and dervish dances (Iranianradio.com)
to Greek pop (Ellinikosfm) and 'classic songs sung by dead French musicians'
(chanteurs.org). And these are just the beginning.
About World Music: a useful directory
http://worldmusic.about.com/od/radiostationsprograms/Radio_Stations_That_Play_
World_Music.htm
All for Peace Radio
Trilingual Palestinian-Israeli station. www.allforpeace.org
Charlie Gillett's World of Music (BBC World Service)
www.bbc.co.uk/worldservice/programmes/charlie_gillett.shtml
New Internationalist Radio
www.newint.org/radio/
Putumayo World Music Hour
www.putumayo.com/en/
Radio 3 World Music homepage
www.bbc.co.uk/radio3/worldmusic/index.shtml
Resonance FM
www.resonancefm.com
World Routes (BBC Radio 3)
www.bbc.co.uk/radio3/worldroutes
Other resources
Popular Art Centre
www.popularartcentre.org
Ramallah-based center that holds an archive of traditional Palestinian song. Hosts
the Palestinian International Festival of Music and Dance.

Index

Index

Index

Index

Index

Index